IMAGES
of America

MOSES LAKE

IMAGES
of America

MOSES LAKE

Freya Hart and Ann Golden,
Moses Lake Museum & Art Center

ARCADIA
PUBLISHING

Published by Arcadia Publishing
Charleston, South Carolina

Printed in the United States of America

Library of Congress Control Number:

For all general information, please contact Arcadia Publishing:
Telephone 843-853-2070
Fax 843-853-0044
E-mail sales@arcadiapublishing.com
For customer service and orders:
Toll-Free 1-888-313-2665

Visit us on the Internet at www.arcadiapublishing.com

This volume is dedicated to Adam H. East, Omar L. Bixler, Helen E. Knapp, Dr. Robert H. Ruby, and the friends of MAC.

CONTENTS

ACKNOWLEDGMENTS

Unless otherwise noted, all photographs in this volume are part of the Moses Lake Museum & Art Center collection and archives. Collections used in this publication were generously donated by Debbie Doran-Martinez, the Moses Lake Chamber of Commerce, Margaret Schiffner, Moses Lake Women's Club, Ann Ebel, Percy Driggs, Tom and Kim Green, Bob and Sue Villalovos, Mick Qualls, the City of Moses Lake, Margie Hattori, Nisei Women's Club, John Powers, Evelyn Amick, Herman Danielson, Alvin H. Smith, Judy Young, and JoAn O'Leary. Many photographs from the Moses Lake Museum & Art Center collection were originally published by the United States Bureau of Reclamation.

We would also like to acknowledge the generous loan of photographs for use in this volume by Don Williams, Harold Hochstatter, Kris Chudomelka, Port of Moses Lake, Columbia Basin Job Corps, Big Bend Community College, Chuck Warren, Joe Nishida, Karen Rimple, and PJ DeBenedetti.

Research materials were donated or loaned by Harold Hochstatter, Ken Goodrich, Clyde Owen, Dennis Clay, Barbara H. Osborne, Kris Chudemelka, Liz Liggett, Mick Qualls, Martin & Rita Seedorf, Helen E. Knapp, and Dr. Robert H. Ruby. Without the conscious effort of these individuals and many more like them, our shared past would be a greater mystery. We would especially like to thank the staff of the Moses Lake Public Library for their time and assistance.

Many thanks are due to Coleen Balent, our Arcadia acquisitions editor, for first approaching the Moses Lake Museum & Art Center to produce this volume. We would also like to acknowledge Kathleen Kiefer, who walked the same path with us as she worked concurrently to produce the *Soap Lake* title, also by Arcadia Publishing. Our knowledge of local and regional history is a little richer today thanks to both.

Lastly, we would like to thank the community of Moses Lake for entrusting the Moses Lake Museum & Art Center with your precious history. It is a humbling experience to know your past, present, and future.

INTRODUCTION

A bizarre topography, punctuated by deep coulees and crumbing rock formations, surrounds Moses Lake. The region, dubbed the "Channeled Scablands" by geologist J. Harlen Bretz in 1922, was born of ancient lava flows and a series of violent Ice Age floods. Moses Lake itself was formed by the action of windblown sand. Large drifting sand dunes blocked the confluence of Rocky Ford and Crab Creeks, creating the third-largest natural lake in Washington State. American Indian legend of a months-long windstorm corroborates this theory. Today, Moses Lake's environment is characterized by a patchwork of pungent sagebrush and fertile farmland.

Prior to the establishment of irrigation in Central Washington, small perennial streams trickled quietly through the arid bunchgrass prairie. Horned lizards baked in the relentless sun, blending seamlessly into the soft muted colors of the shrub-steppe. Overhead, the skies were empty but for the updraft acrobatics of winged hunters tumbling through thirsty clouds. Ancient petroglyphs marked the presence of early man in the Columbia Basin.

Untold generations of Native American bands wintered at camps on the Columbia River. They followed the bloom of spring inland along thin ribbons of moisture. Carrying digging sticks and flat woven bags, they harvested the native plants, bitterroot, and camas bulbs. Called the "between people," the Columbia-Sinkiuse band enjoyed a nomadic lifestyle traveling a seasonal path between the shores of the Columbia River and the Grand Coulee. The remains of ancient pit houses tell tales of their summers collecting the eggs of waterfowl and drying roots along the shallow shores of Moses Lake.

The lake, Moses Coulee, and the City of Moses Lake bear the biblical name given to Chief Moses, the last leader of the Columbia-Sinkiuse band. With the encroachment of white settlers in the Columbia Basin, Moses's band agreed to move north to the mineral-rich region of Lake Chelan. Pres. Rutherford B. Hayes established the Columbia Reservation in Okanogan County shortly after Moses's diplomatic journey to Washington, DC, in 1879. Under intense pressure by miners and angry white settlers, the Sinkiuse were given the choice to move to the Colville Reservation or accept land allotments. The Columbia Reservation was reopened for white settlement in 1886. Chief Moses died on the Colville Reservation in 1899.

Moses Lake is geographically located in the Cascade rain shadow, a region characterized by warm, dry winds and scanty precipitation. The heavy rains that typify the Pacific Northwest have difficulty escaping the pull of the 10,000-foot Cascade Range. Moisture-laden winds traveling eastward release their precipitation on the windward slopes of the mountains. The result is a leeward rain shadow and the desertlike climate of the Columbia Basin.

Moses Lake's annual rainfall is less than eight inches. However, a period of unusually wet weather attracted early immigrants to Moses Lake and Grant County around the turn of the century. Dryland farming operations produced bumper crops of wheat and rye during the several years of heavy rains. Settlers who painstakingly cleared fields of the thick layer of ancient flood debris and mature sagebrush saw their profits dry up with the rains. Some modest success was enjoyed

by those who settled close enough to existing waterways or drilled deep wells. By 1912, a handful of orchards lined the shores of Moses Lake, fed by small private irrigation projects.

It has been said that "whiskey is for drinking, water is for fighting over." Numerous business interests claimed rights to Moses Lake's water. In 1909, court actions began to address the slew of questionable filings. Far-flung interests in agriculture, realty, and even cheese-making tried their hands at fortune, but most could not afford to keep the water pumps running. In 1911, F.H. Nagel, a representative of Brunder's Grant Realty Company, arrived in nearby Ephrata claiming he would plat a prosperous city near Moses Lake that would soon dwarf Wenatchee. He called this new town Neppel.

In 1922, the tiny town of Neppel was hardly the metropolis imagined by the Grant Realty Company. No herd law existed, and horses, cows, and pigs ran unchecked through the streets. In 1913, in anticipation of their land sale, the Brunder fortune laid out the townsite, constructed a 24-room hotel, and set up gasoline-powered water pumps. However, on the morning of the sale, signs appeared all around town reading, "You may buy the land, but you cannot buy the water—we own it," and signed Ham, Yearsley, and Ryrie. The land sale was a total flop. True growth was nearly impossible until water rights were reassigned to the Moses Lake Irrigation District in 1929.

In 1917, a controversial proposal began to gain popularity in the Columbia Basin. Ephrata attorney William M. Clapp proposed building a concrete dam on the Columbia River, creating a reservoir and pumping system from which to irrigate farmland. The project gained support from local businessmen, eventually winning national favor in Washington, DC. Construction on Grand Coulee Dam and the giant Columbia Basin Irrigation Project began in 1933.

Despite the approaching arrival of abundant water, Neppel was still wholly isolated. In 1924, a commercial club formed to address the ongoing issues of water rights and road conditions in Neppel. The commercial club rallied to advocate a highway project connecting Ellensburg to Spokane. Highway 10, which follows the route known as I-90 today, was completed in 1936, bringing cross-state traffic through the tiny town. In 1938, Neppel's 302 residents voted to incorporate, changing the town's name to Moses Lake.

In 1940, rumors began to circulate of an Army Air Corps interest in the region's clear skies and strategic defensive position. With the advent of World War II, Moses Lake Army Air Base became a hub of wartime activity, training pilots for P-38 fighters and B-17 combat crews. Moses Lake grew from 326 residents in 1940 to 2,679 in 1950. That same year, the air base was renamed Larson Air Force Base in honor of World War II flying ace Maj. Donald A. Larson of Yakima, Washington. The skies over Moses Lake hummed with military activity until the base was decommissioned in 1966.

In 1952, the Columbia Basin Project waters raced across the desert like the Ice Age floods. After the arrival of irrigation, Moses Lake's population quadrupled. The birth of modern agriculture in the basin is often described as a passive "bloom." In reality, it was a finely orchestrated revolution born on the drafting table of engineers and in the arena of national politics. The waters of the Columbia River were harnessed, empowering farmers in the Columbia Basin to overcome its climatological shortcomings. An era of phenomenal prosperity began in Moses Lake, led by its king—agriculture.

One

THE HARDEST WATER

IN THE NORTHWEST

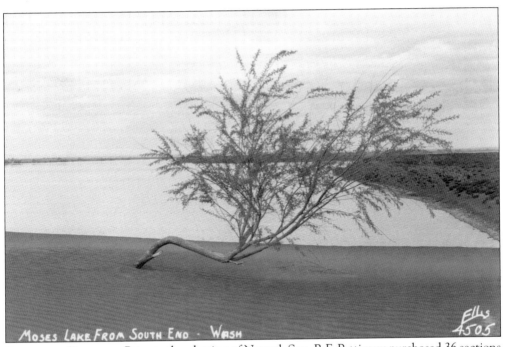

PETTIGREW PROPERTY. Prior to the platting of Neppel, Sen. R.F. Pettigrew purchased 36 sections of land adjacent to Moses Lake from the Northern Pacific Railway for 10¢ an acre. In 1908, he built a dam at the lake's southern outlet and established 160 acres of apple orchards fed by Moses Lake irrigation. In 1910, Pettigrew became a millionaire when he sold his undeveloped lands to Milwaukee's Brunder family. (Photograph courtesy of Don Williams.)

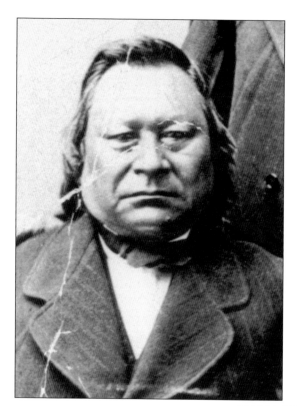

CHIEF MOSES. Born Loolowkin in 1829, Chief Moses, leader of the Columbia-Sinkiuse band, gave his name to Moses Lake. At the age of 9, he was sent to the Spalding Mission in Lapwai, Idaho, where he received his biblical name. After assuming the role of tribal chief in 1858, he worked tirelessly to lead his people through the ripple effect of change that white settlement brought to the basin.

CREEK BREAK. Moses Lake pioneer J.C. White recalled the annual move by Chief Moses and his Sinkiuse band to their summer encampment. A great rock marked the camp southwest of Rocky Ford Creek between Moses Lake and Ephrata. Chief Moses and his people would trade with tribes traveling from Montana. Here, two members of the Dills family pause on the bridge over Rocky Ford Creek in 1920.

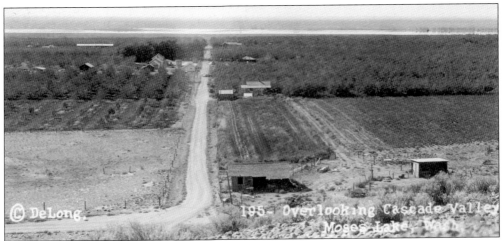

APPLE CROP. Cascade Valley is located between Parker Horn and Lewis Horn, two of the three irregularly shaped arms of Moses Lake. Parker Horn is named for a horse trader who settled near a spring between the two inlets in 1897. A handful of early settlers pumped water from Moses Lake to irrigate orchards in Cascade Valley. In 1920, Neppel's apple crop totaled some 150 railcar loads.

FRUITFUL ACRES. The apple market in Central Washington was already strong thanks to the success of Wenatchee orchards. In 1906, C. Lewis, for whom Lewis Horn is named, planted a 2,000-tree orchard in Cascade Valley, irrigated by a steam boiler pump. Tichacek and Sons purchased the orchard from Lewis. This c. 1910 photograph of Charles Tichacek was used to advertise land tracts by the Grant Realty Company.

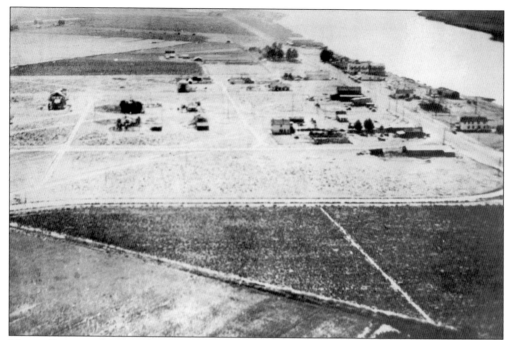

NEPPEL PLATTED. In 1911, the Brunders, who owned the Grant Realty Company, sent F.H. Nagle to look after their land holdings and establish a planned community by Moses Lake. Nagle was charged with setting up two gas-powered pumping plants to supply water and sell lots in the newly platted town of Neppel, shown here in 1941. In 1912, the Milwaukee Road (Chicago, Milwaukee, St. Paul & Pacific Railroad) arrived in anticipation of the big land sale.

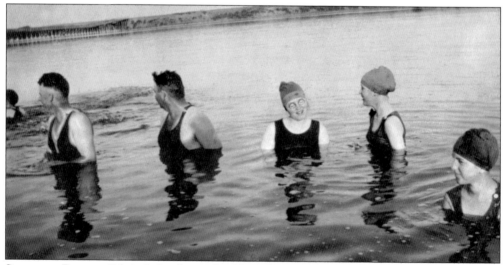

SWIMMING PARTIES. Edwin Leland moved to Neppel in 1922 and operated the general store until 1931. To escape the summer heat, Leland closed his businesses for the day and the entire town would head to the lake. He also claimed there was gold in the lake. "At one of our swimming parties I threw a ball and my gold wedding band came off my finger. I never did find it."

This is at moser Lake the 4th of July when they were at dinner

PENNED BY POSTMISTRESS. By 1910, the Columbia Basin was home to 6,500 landowners, 51 rural schoolhouses, and 21 post offices. The Neppel Post Office was established in 1911 and was moved in 1912 into the Moses Lake Inn, which was about one mile from the first Moses Lake Post Office, set up in 1906 on MacDonald Hill (Nelson Road). Postmistress Jessie MacDonald wrote this postcard in 1907.

DON'T SWEAT IT. A record high of 105 degrees was set in Neppel on June 4, 1924. That summer, the lightest wheat crop ever known for the region did little to help farmers even as wheat prices rose. Despite the rising pressures, the Dills family keeps cool at this lakeside gathering in the early 1920s.

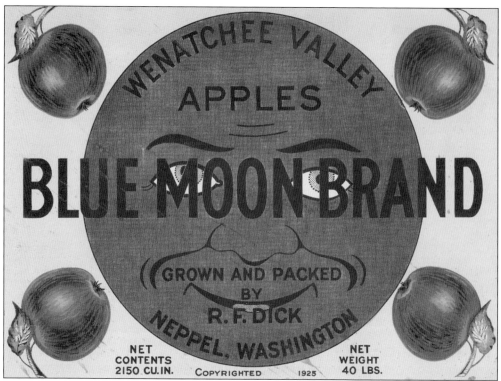

WENATCHEE VALLEY APPLES

BLUE MOON BRAND

((GROWN AND PACKED))
BY
R. F. DICK

NEPPEL, WASHINGTON

NET CONTENTS 2150 CU. IN. COPYRIGHTED 1925 NET WEIGHT 40 LBS.

BAD APPLE. By the time the Great Depression hit in 1929, Neppel and the entire Columbia Basin had already been suffering its effects for nearly a decade. Neppel's orchard and fishing industries shut down as costs skyrocketed and prices plummeted. Bills for guaranteed freight to dwindling Eastern markets came due and many growers left as the banks foreclosed on family farms. Grant County's population fell from its 1910 high of 8,700 to 5,600 in the 1920s. Many Moses Lake orchards were pulled out and replaced with fields of potatoes. The improbable dream of a federally funded irrigation plan encouraged those who remained to promote the construction of Grand Coulee Dam. Spirits appear to be high on the C&O Apple Orchard in Hiawatha Valley (below) about 1910. Blue Moon Brand apples (above) were grown and packed in Cascade Valley.

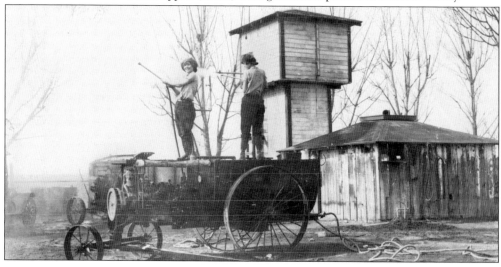

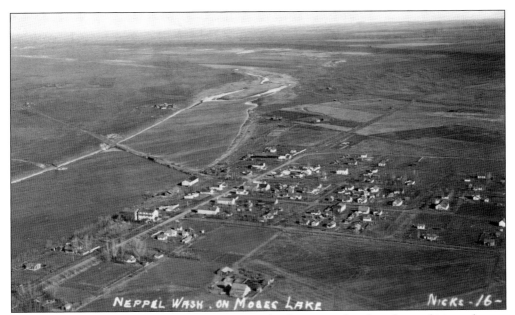

NEPPEL WASH, ON MOSES LAKE NICKS-16-

BRUNDER'S BLUNDER. The Brunder-run Grant Realty Company abandoned its ambitious plans to outpace the growth of Wenatchee in tiny Neppel. The company built and fully outfitted a cheese factory across from the train depot. However, as soon as Scandinavian immigrants recruited to run nearby dairies learned of the high price of irrigation water, they left. Compromised by legal troubles, lots in Neppel sat largely unsold until 1927.

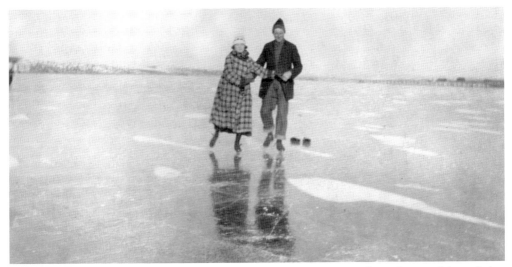

A CHILLY TALE. Typical winter conditions can freeze up to 18 inches of ice on Moses Lake. Extreme winter temperatures have been recorded, reaching 20 below zero. Historian Helen Knapp recalled the school bus from Cascade Valley used to take a shortcut across the frozen lake into town. Here, Neva and Paul Dills ice-skate near the piling bridge connecting the peninsula and Westlake, constructed by the county in 1913.

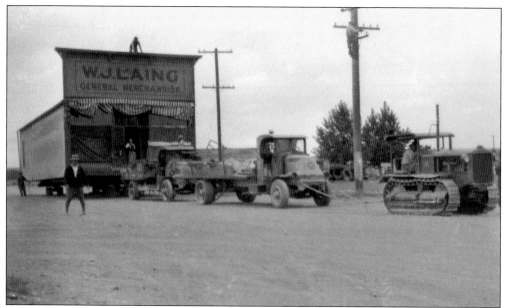

RETURN TO SENDER. This building was one of many moved from the declining town of Ruff to Moses Lake in 1931. Owner W.J. Laing stands in the doorway. Ruff's post office was moved to Poggensee's lumberyard, and the White Hotel built in 1900 was moved to its present location at 415 Alder Street in 1944. (Photograph courtesy of Harold Hochstatter.)

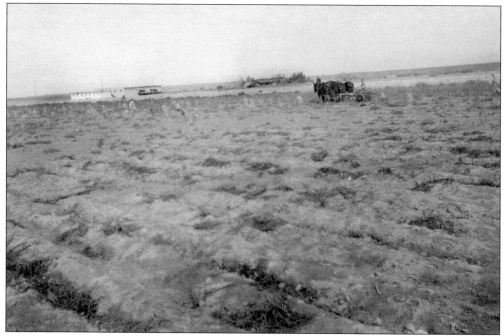

CENTRALIZED PROCESSING. Most early Neppel apple growers handled their own crops, but in 1922, Clyde and Edward Brown built the Western Cold Storage building, about one block from where Frontier Junior High School stands today. With the business defunct by 1938 following the apple-market crash, Fred Matson of Puyallup purchased and renovated the property for handling potatoes. (Photograph courtesy of Harold Hochstatter.)

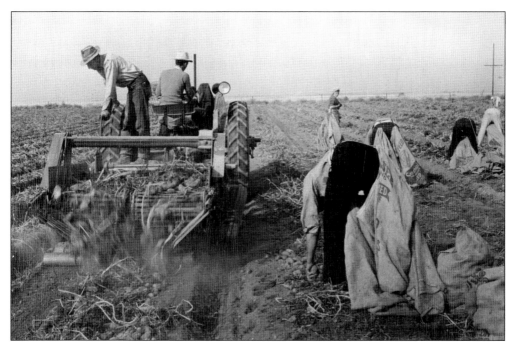

DIGGING SPUDS. By the 1940s, mechanical potato-diggers slowly eliminated the grueling work of digging potatoes by hand. Tractors pulled either one- or two-row diggers. Steel lags created a circular bed that sifted the dirt, and the potatoes would fall off the end. Pickers followed behind filling the sacks attached to their belts. Potatoes jumped from $15 to $20 per ton in 1941.

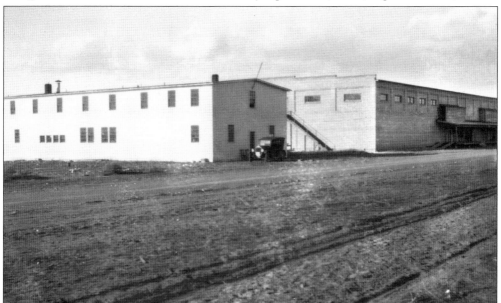

HOT AND COLD. The Western Cold Storage Company warehouse, shown here in 1929, burned on September 26 in a series of major arson fires that terrorized Moses Lake from August to October 1953. The framed building in the foreground was a dormitory for fruit workers. The final of three disastrous fires to hit the Western Cold Storage building destroyed the brick warehouse in 1957. (Photograph courtesy of Harold Hochstatter.)

ADVERTISING THE WEST. The pennant postcard was a stock card carried by a publisher that could be customized for individual communities. Real-photo postcards were another popular form of postcard introduced by Kodak about 1903. Postcard-size film allowed the general public to print photographs onto postcard backs. Promotional campaigns were led to attract new citizens to the newly formed Grant County in 1909.

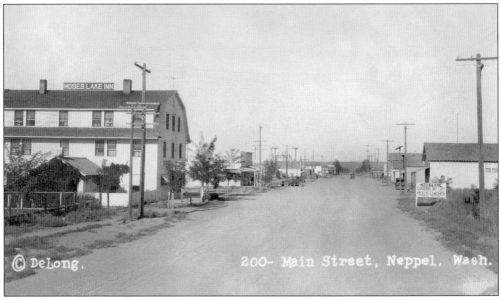

ON BROADWAY. The Moses Lake Inn was located at the corner of West Broadway Avenue and Ash Street, the location of the present Sand Bar Tavern and Taqueria Mi Tierra restaurant. Originally named the Grant Hotel, it was built in 1912 by the Ott Family of Wenatchee and was equipped with private and public bathrooms, steam heat, and electric lights. It was purchased by Loren and Margaret Harris in 1922.

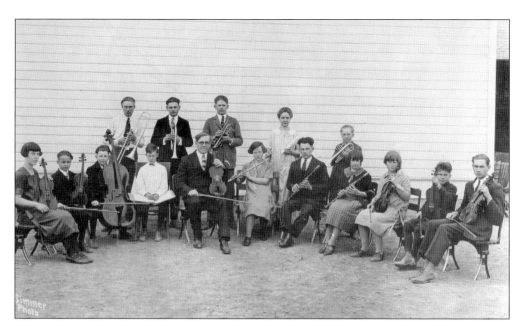

A Class Act. Neppel school records date to 1913, but pioneers recalled schools as early as 1906. The Hiawatha School is shown below around 1908. Margorie Ebel recalled there were nine students attending Hiawatha School when she was in the third grade. They burned apple wood and made soup on the school's potbellied stove. State-funded schoolhouses gradually replaced the homestead schools under Washington's "Barefoot Schoolboy Law," which provided state funds for each child who attended public school. In 1913, the Neppel School had two rooms. An annex was added in 1921. The ninth grade was the only high school grade offered. In 1922, Moses Lake area schools had less than 150 students. The Neppel School Symphony Orchestra poses above in 1925.

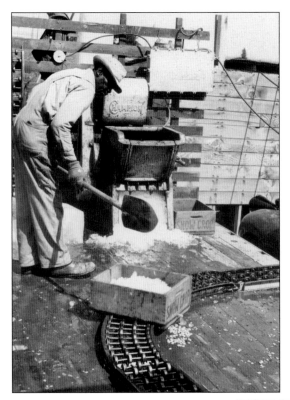

BRINGING THEM ICE. Chemical refrigerants were not developed until the late 1920s. Instead, ice was harvested during the winter and packed in sawdust in icehouses. It was used for keeping milk, butter, and eggs cool, and for making ice cream. It was never used in drinking water. Harvesting ice was a typical winter chore at the turn of the century in Moses Lake.

GEFILTE FISH. Moses Lake is on average 18 feet deep, reaching up to 40 feet deep, the perfect warm, shallow waters for no one's favorite fish—carp. Seine collecting proved to be an effective method of harvesting great numbers of carp. Around 1914, the Minnewash Fish Company began sending ice-cooled railcars full of live roiling carp to Eastern markets. (Photograph courtesy of Harold Hochstatter.)

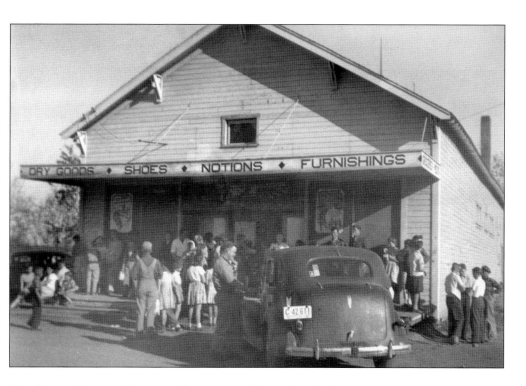

THE SOCIAL CENTER. The general store owned by Emil Rudolf (above) once operated as part of the Red & White grocery store chain. In later years, the storefront windows were blocked out, and movies were projected from a booth located behind the building's small front window. It stood where Furniture West now stands on Broadway Avenue, between Ash and Division Streets. A building on Division, popularly known as "The Auditorium," (below, on the far right) was the nucleus of social life in Neppel. Saturday night dances, piano, fiddle music, and the occasional fight kept things lively. At midnight, the Women's Club sold desserts and lunches. Paul Guffin (left), Velmer Winn (center), and Delbert Guffin (below) pose on Third Avenue in 1928. (Above photograph courtesy of Harold Hochstatter.)

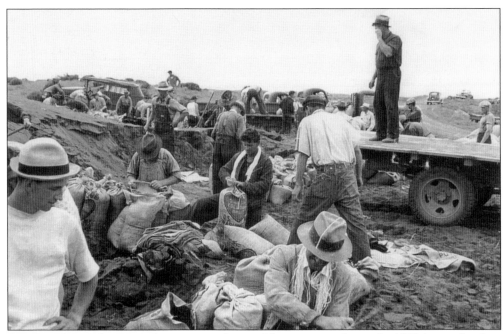

DAM IT. Moses Lake was under constant threat of dangerous washouts. In 1925, heavy flooding washed out the Pettigrew Dam. For 48 hours, every available man threw sandbags (and almost everything else he could find) into the breach. In 1928, H.R. Smith filed for water rights, as the previous holdings were considered defunct by most after the washout. Smith reassigned his rights to A.E. Rudolff, who reassigned them to the newly formed Moses Lake Irrigation District in 1929. The district constructed a new wooden dam in 1930. In 1941, the enormous effort of 1925 was repeated when flooding again breached the dam. As the Columbia Basin Irrigation Project became reality, effects of irrigation and fertilizer on water quality expanded the district's focus, which became the Moses Lake Irrigation and Rehabilitation District in 1962. (Photographs courtesy of Harold Hochstatter.)

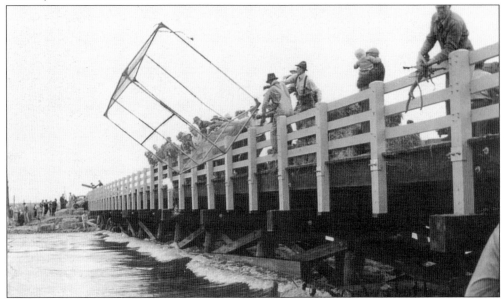

THE SILENT SERVANT. A generator powered a handful of streetlights and residences from dusk until midnight as early as 1912. Neppel did not receive 24-hour electricity service until the private utility company Washington Water Power turned the lights on in 1922. The substation is pictured here. The Grant County Public Utility District was formed in 1938, when it acquired the Washington Water Power Company. (Photograph courtesy of Harold Hochstatter.)

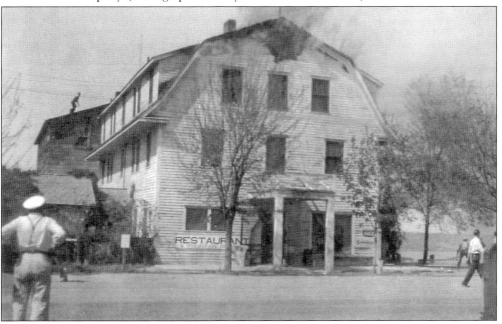

FIFTY-ROOM HOTEL BURNS. On April 29, 1939, the first major fire in Moses Lake destroyed the Moses Lake Inn on Broadway Avenue. A bucket brigade formed to the nearby shoreline, but the fire totally consumed the hotel, which also housed the town post office. Loren Harris was the inn's proprietor and Moses Lake's postmaster. (Photograph courtesy of Harold Hochstatter.)

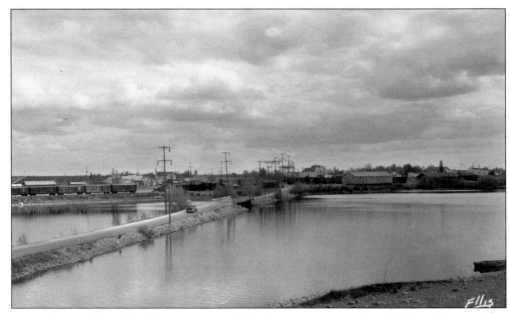

ALDER STREET FILL. The lake crossing at Alder Street appears in the 1917 *Grant County Atlas*, and was likely built around 1911. Almost every year, seasonal flooding would wash out the fill, forcing people to cross on boats or ford the stream near Parker Horn. Shown here about 1940, the Alder Street crossing opened to vehicle traffic in 1924.

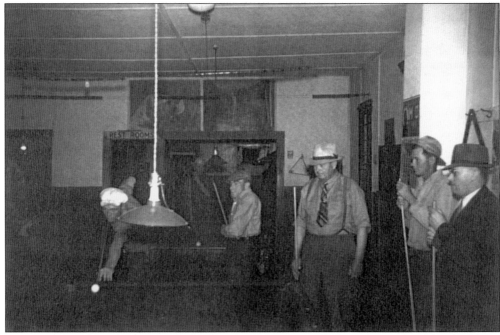

LITTLE BROWN JUG. This photograph was taken in Danny's Tavern, one of the oldest buildings still standing in Moses Lake. When wheat harvests were poor, a handful of Ritzville wheat farmers took up bootlegging and produced jugs of whiskey to sell to the apple pickers. Despite the restrictions of Prohibition, some Moses Lake orchard owners had a hard time keeping their picking crews sober. (Photograph courtesy of Harold Hochstatter.)

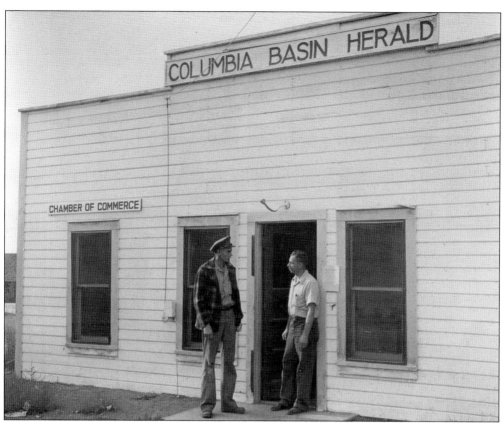

GETTING DOWN TO BUSINESS. In 1916, the road conditions in Neppel and all of Central Washington were abysmal. A trip from Ephrata to Ellensburg averaged eight hours. In 1924, Frank Lees, Jack White, George Hochstatter, and Loren Harris formed a Commercial Club to seek better road conditions and support the budding Columbia Basin Irrigation Project. The group reorganized as the Moses Lake Chamber of Commerce in 1945, which shared a building with the *Columbia Basin Herald*. Clifford Elder (left) is shown above with Archie Trenner, the newspaper's editor. In 1936, Highway 10 was built connecting Ellensburg to Spokane, bringing cross-state traffic through Neppel. That same year, the Washington Motor Coach Company began running busses on the Highway 10 route through Neppel. Highway 10 later became part of the transcontinental Interstate 90, connecting Seattle to Boston.

25

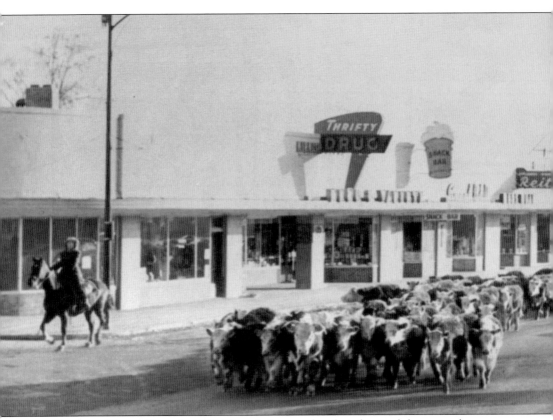

THE LAST NEPPEL DAYS. In 1952, Moses Lake paved and modernized the entire downtown center, including new concrete sidewalks and a stoplight at the intersection of Broadway Avenue and Alder Street. The town was several weeks into a spring cleanup for the upcoming Columbia Basin Water Festival, scheduled for May 22–June 1, 1952. Chores were assigned to several hundred volunteers in preparation of "B-Day," or Building Day, for the Farm-in-a-Day festival project on May 29. May

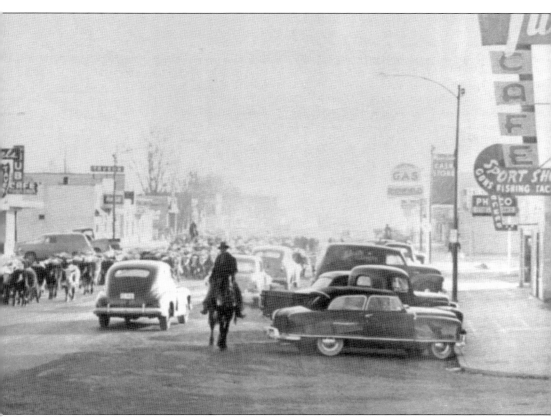

Miller Wenger (far left) leads what was likely the last cattle drive down unpaved Broadway Avenue in 1952. In 1949, May moved to Moses Lake with her husband, Clyde Miller, where they owned an alfalfa ranch, a cattle feed business, and the Millerville rental company. She served as the president of the Grant County Cowbelles and was a member of the Cattleman's Association.

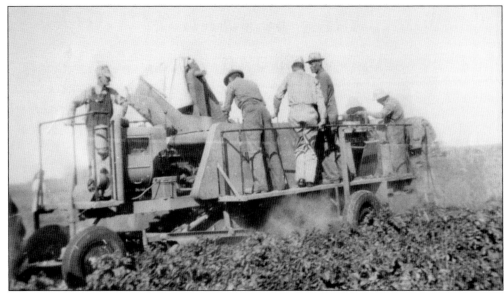

MECHANIZED FARMING. In the mid-1930s, the diesel tractor came onto the market. While a combine used to require the power of up to 40 horses, self-propelled tractors and combines gradually replaced horses and working farm animals. This is the first experimental potato-harvester in Moses Lake about 1943. The photograph was taken in a field between West Broadway Avenue and Ivy Street on the Driggs farm.

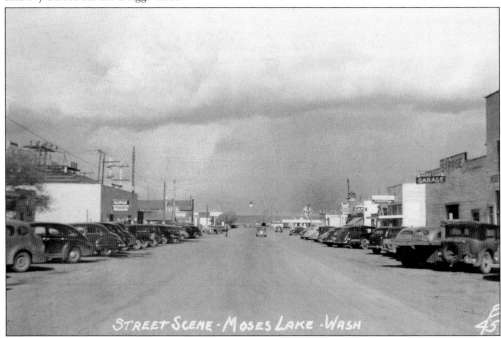

NEPPEL RENAMED. With irrigation rights secured by the Moses Lake Irrigation District, the town of Neppel turned its focus to building further infrastructure. The Ladies Aid and Missionary Society proposed incorporating, which would enable the town to issue revenue bonds to improve the town's water system. Neppel's citizens voted to incorporate and changed the town's name to Moses Lake in 1938. The election also established a mayor-council form of government.

Two

Moses Lake
Desert Oasis

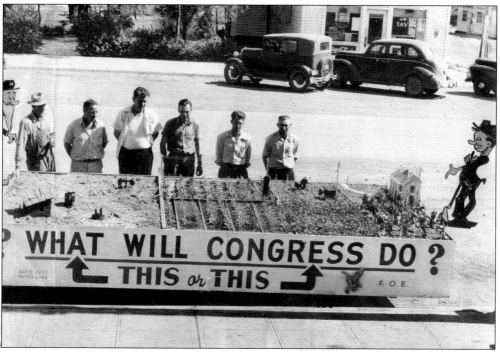

Waiting on Water. World War II erupted shortly before construction on Grand Coulee Dam was completed, and emphasis shifted from the dam's primary purpose of supplying irrigation water to the wartime demand for power. This float built by the Moses Lake Eagles Lodge No. 2622 received an honorable mention in the Wenatchee Apple Blossom Festival Parade about 1947. Moses Lake area farmers would not receive project water until 1952.

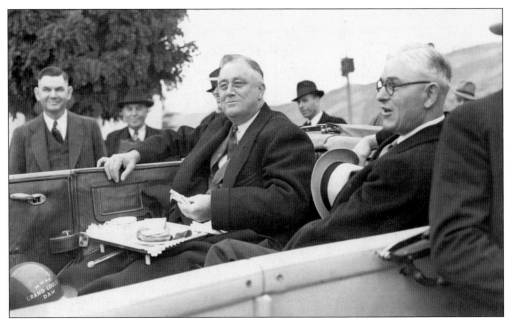

NEW DEAL SECOND CHANCE. Rejected by Pres. Herbert Hoover in 1932, the Columbia Basin Irrigation Project was at the forefront of Pres. Franklin D. Roosevelt's New Deal. The project promised to provide relief from the seemingly bottomless Great Depression for thousands of small, family farms. The first stakes were driven for the axis of Grand Coulee Dam in 1933. President Roosevelt (left, in the car) visited the dam twice during its construction.

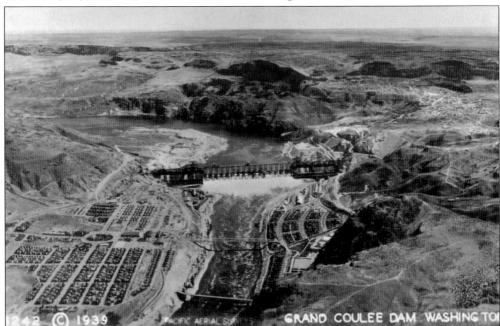

THE BIGGEST THING ON EARTH. Moses Lake was only indirectly affected by construction on Grand Coulee Dam. Workers from all over the country passed through town on their journey north, but most did not stay. Ed Ebel of Moses Lake worked as a concrete finisher on the dam. When it was completed, Grand Coulee Dam was the largest concrete structure in the world.

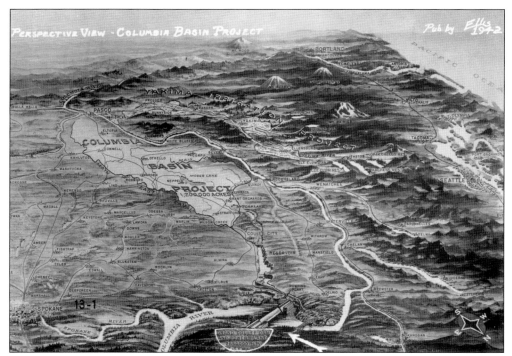

PROJECT STATISTICS. Today, the Columbia Basin Irrigation Project serves over 671,000 irrigated acres, a little over half of the 1,029,000 acres originally authorized by Congress. It diverts 2.5 million acre-feet of water from its main reservoir, Franklin D. Roosevelt Lake, accounting for two percent of the Columbia River's annual flow. On average, Grand Coulee Dam produces 21.2 billion kilowatt-hours and furnishes a large share of the Pacific Northwest's power.

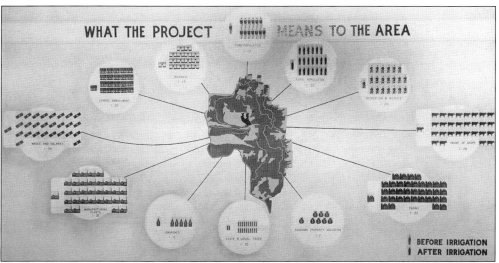

LAND OF PLENTY. The project, managed by the United States Bureau of Reclamation, is still the nation's largest water reclamation project. When it was conceived, the project was considered to be the greatest potential source of wealth likely to attract a million newcomers to the Pacific Northwest. Cumulative product values are estimated at $2 billion annually. From school enrollment to manufacturing, the project has positively affected Moses Lake's growth.

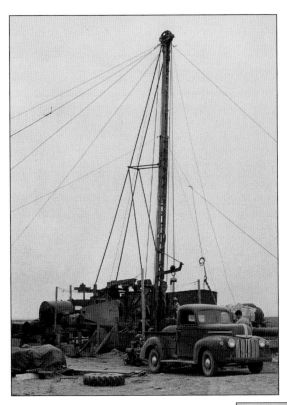

EXPERIMENTAL FARM. The 80-acre United States Bureau of Reclamation Predevelopment Farm two miles east of Moses Lake tested the productivity of various irrigated crops from potatoes to corn from 1947 to 1954. While water from the Columbia Basin Irrigation Project was still years away, the farm was supplied by this 142.5-foot well. During a 60-hour test, the well produced 1,050 gallons per minute.

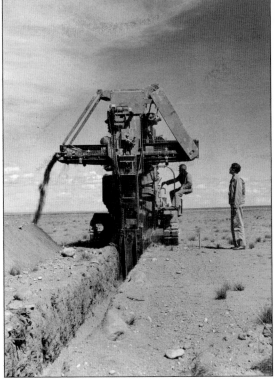

MAKING CONNECTIONS. This trenching machine is excavating a line into which a 15-inch concrete pipe will be used to carry irrigation water to crops on the Moses Lake Predevelopment Farm. The Columbia Basin Irrigation Project area currently contains over 2,360 miles of canals and laterals and 3,438 miles of drains and wasteways.

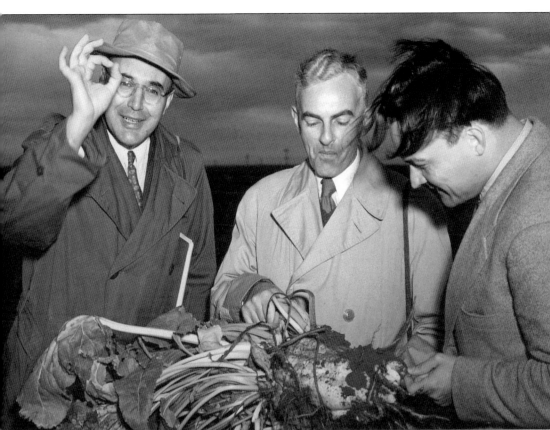

QUEEN BEET. Giant sugar beets received accolades from three representatives of the Economics Cooperative Administration making a United States tour from French Equatorial Africa and Madagascar on October 25, 1950. They are, from left to right, Kellerman, Cialina, and Minjoz. This field yielded an excess of 30 tons per acre. Based on the success of crops, like this one at the Moses Lake Predevelopment Farm, it did not take industry experts long to conclude that the Columbia Basin would be the next headquarters for sugar beets in Washington. In 1952, the Utah-Idaho Sugar Company announced its plans to build a $7-million processing plant three miles east of Moses Lake on Wheeler Road. Acreage allotments for sugar beets doubled in 1953 after announcement of the new processing plant. Sugar beets would become one of the most successful crops in Moses Lake through the 1970s.

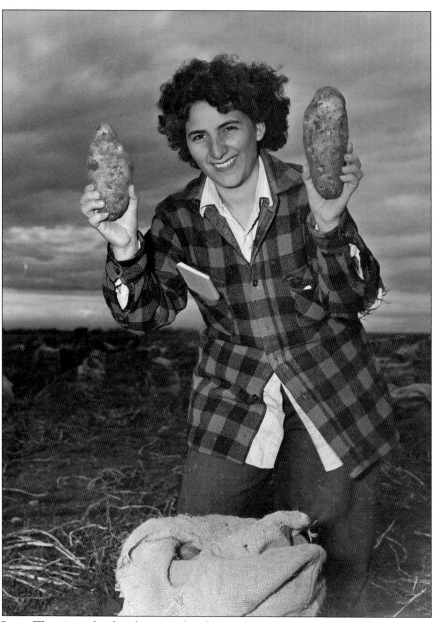

King Spud. The mineral-rich volcanic soil and long growing season in the Columbia Basin make it ideal for potato farming. Eastern Washington produces the highest yield per acre of potatoes in the world, accounting for 20 percent of all United States potatoes. Potatoes and wheat alternate as Washington's largest agricultural crop. Established in 1956, the Washington State Potato Commission office operates out of Moses Lake. In 1955, V.A. Powell, manager of the Menan Starch Company in Idaho Falls, Idaho, announced plans to open another plant in Moses Lake. The Menan Starch Company plant shipped culled potatoes to paper mills for use as a bonding agent, to the Campbell Soup Company in the Midwest as filler in tomato soup, and to Hawaii for use in macaroni products. The by-product, potato pulp, was shipped to the local A&W Feed Lot for cattle feed. Potato pickers were in short supply at the Moses Lake Predevelopment Farm in 1950. This unidentified picker hails from Wallace, Idaho.

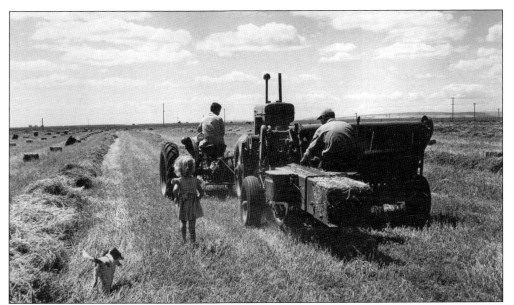

FIELD DAY. Two men bale alfalfa on the Moses Lake Predevelopment Farm in 1949. After allowing the cut alfalfa to cure in long windrows, the hay is baled. Alfalfa is a flowering plant in the pea family. It is cultivated for use as forage for livestock and as a cover crop. A cover crop is plowed under before reaching full maturity to improve soil quality.

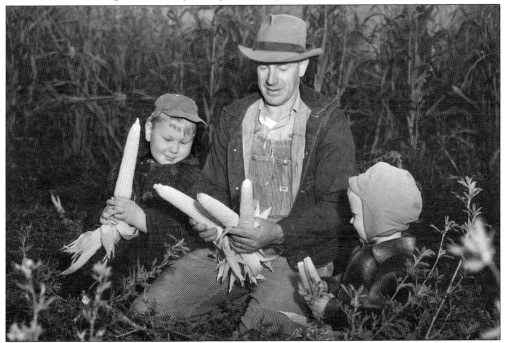

EXPLOSIVE RESULTS. A field of nine-foot-tall corn attracted hundreds of onlookers, farmers, and would-be farmers on Dedication Day, October 4, 1947, at the Moses Lake Predevelopment Farm. Here, farm operator Harper Keebaugh displays ears of popcorn on the cob in 1952. Popcorn became increasingly popular during the Great Depression as sugar rationing diminished candy production.

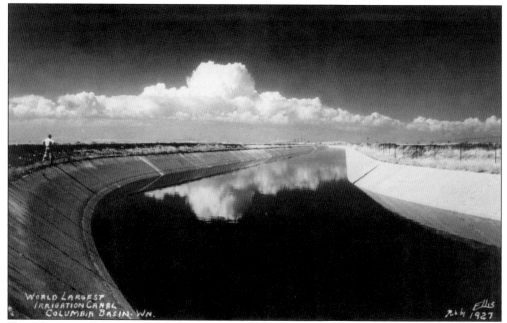

THE MAGIC OF WATER. Everything about the Columbia Basin Irrigation Project bespoke of its enormous magnitude. Grand Coulee Dam was praised as the Eighth Wonder of the Modern World. The West Canal (pictured here) was touted as the world's largest irrigation canal. It measured 38 feet wide at the bottom and 95 feet at the top. Every second, 5,100 cubic feet of water passed through.

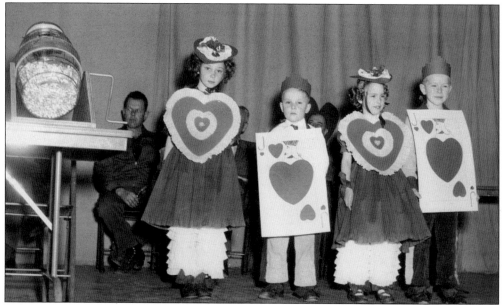

LUCKY VALENTINE. The children of veterans who won government farm lots drew numbers from a pickle jar on Valentine's Day 1952 to determine the lucky recipients of 38 farm units in Moses Lake. Pictured, from left to right, are Jane Johnson, Billy Johnson, Eileen Peters, and Virgil Minden. The first drawing for 30 farm units in the Columbia Basin Irrigation Project was in 1951 in Block 40, located five miles north of Moses Lake.

Deserving Veteran. The Veterans of Foreign Wars sponsored a national search to award the Farm-in-a-Day feature of the Columbia Basin Water Festival marking the ceremonial arrival of irrigation water in Moses Lake—an entire farm including planted fields, a farmhouse, and outbuildings, constructed in 24 hours. Donald Dunn, former Kansas Cottonwood River flood victim, was selected as the nation's most deserving veteran and winner of the turnkey farm.

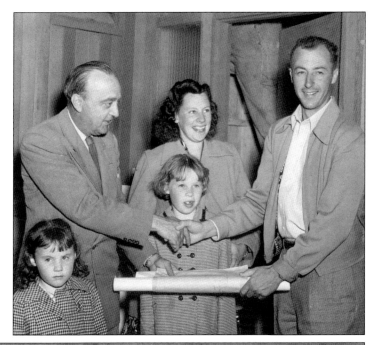

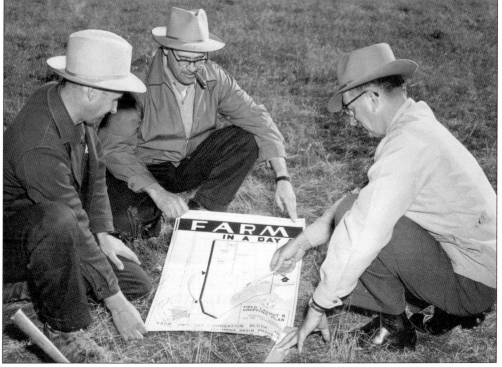

The Shape of Things to Come. Farm-in-a-Day development committee members meet to put the finishing touches on plans for the $50,000 farm that will be constructed in 24 hours, starting at the stroke of midnight on May 29, 1952. They are, from left to right, E. Pershing Vance of Moses Lake, soil conservation service; George M. Delany of Ephrata, county extension agent; and John L. Toevs of Ephrata, Bureau of Reclamation chairman.

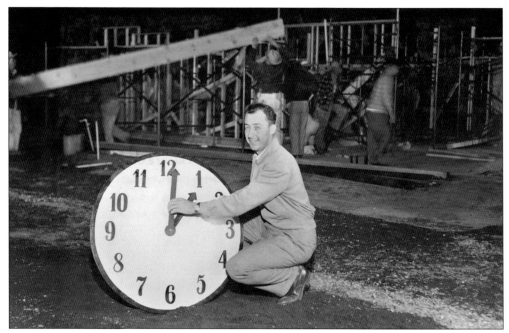

A 24-Hour Farm. Donald Dunn sets the clock one hour after work began on the Farm-in-a-Day project. About 200 workmen donated their effort to develop the 80 irrigable acres and farmhouse. Dunn slept under the completed roof of the fully furnished, 1,500-square-foot home only 24 hours later. The home was also stocked with $250 worth of groceries, donated by Lemon's Market of Moses Lake.

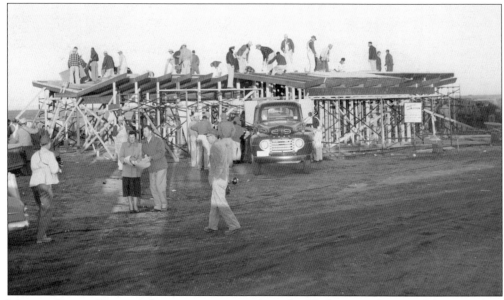

Modern Dream Home. A five-man committee from the Washington chapter of the American Institute of Architects designed the seven-room farmhouse to be both utilitarian and picturesque. It featured both a guest and farm entrance, with facilities for canning, automatic laundry, and a distinctive dihedral roof, commonly called butterfly style. The home begins to take shape at dawn.

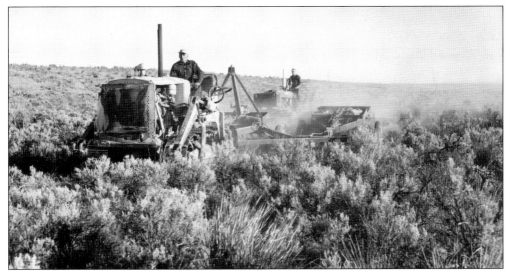

SAGEBRUSH SUNRISE. By late afternoon, these sagebrush fields would be fully irrigated and planted for the season's first crops of alfalfa, field corn, oats, and red clover. These tractors represent two of the approximately 50 machines that donated their assistance in the farm development. Dozens of Moses Lake and other Pacific Northwest cities donated goods and services to support the monumental project.

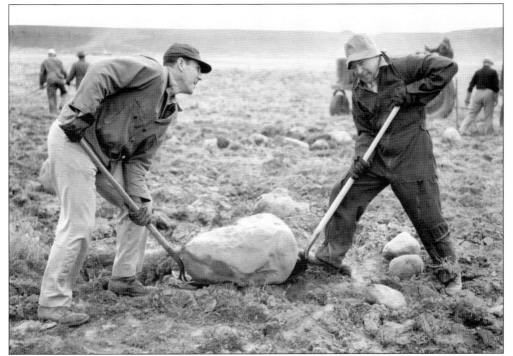

HARD ROW TO HOE. At the turn of the century, a few unscrupulous real estate agents were desirous to rid themselves of rocky land. One such realtor explained that the rocks were necessary for the coloring of the apples. Many speculators bought acres of scab rock sight unseen shortly before the irrigation project was completed. Here, Farm-in-a-Day volunteer laborers break themselves against ancient flood debris before turning to heavy machinery.

LOFTY EXPECTATIONS. Expectations for the 30-year-old war veteran Donald Dunn were high. Farm-in-a-Day attracted national public interest with columns in the *New York Times*, and radio, television, and newsreel coverage. At least 50 reporters stayed on through the Dunn's first week on the farm. His first-year crop profits and full audit report were front-page news in Moses Lake.

A SYMBOLIC ACT. Undersecretary of the Interior Richard D. Searles (second from left) and Moses Lake Farm-in-a-Day recipient Donald Dunn (third from left) look on as Bureau of Reclamation commissioner Michael W. Strauss turns the wheel marking the symbolic first delivery of water to the Columbia Basin Irrigation Project at 5:00 p.m. May 29, 1952. Members of the press and project workers crowd in closer for a better view.

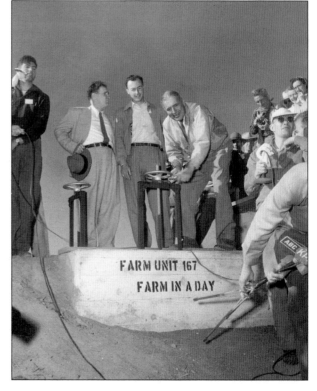

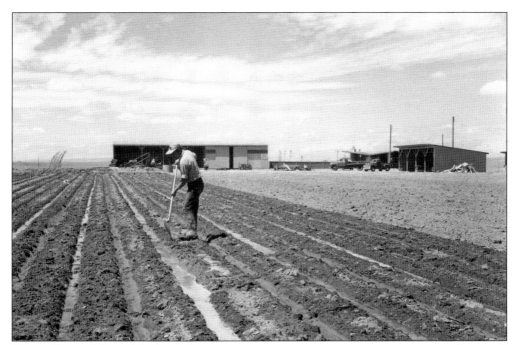

WATER FLOWS. Most of the land that was open to irrigation project water was privately owned. Some private landowners chose to be omitted because they already had their own canals and pipelines fed by lake irrigation or wells. Publically owned acreage was distributed to war veterans by a lottery. This Farm-in-a-Day view is an example of furrow irrigation, a gravity system that pulls water down channels of sloped rows.

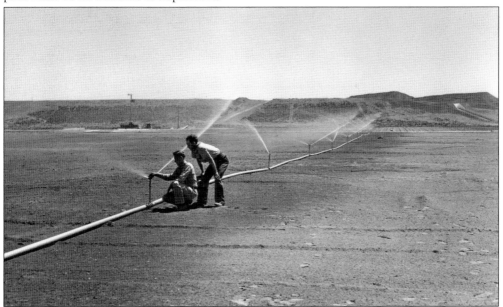

UNDER PRESSURE. Frank Shinn, left, and Elwood Guenther examine the sprinkler system used on Farm-in-a-Day. Similar to a basic garden sprinkler, a portable system of aluminum hand line and impact-type sprinkler heads pump water under pressure. Later, motor-driven wheel line and center-pivot irrigations systems made it possible for larger farms to save on labor.

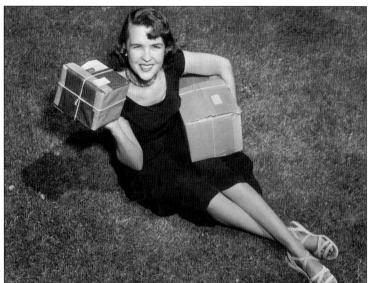

GENEROUS SPIRIT. Sandra Larson, Moses Lake Chamber of Commerce secretary, holds gifts from Maine and Alaska, two of many arriving daily from 48 states and United States territories for the Farm-in-a-Day. The Washington State Apple Commission sent gifts of Washington apples to the governor of each state or territory in return.

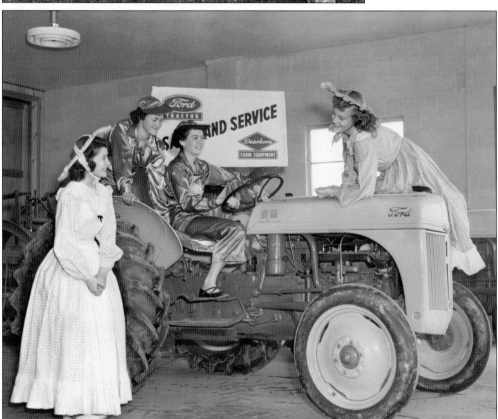

PRETTY PAYLOAD. Moses Lake High School students are eager to present over 17 pieces of heavy farm machinery donated to the Farm-in-a-Day. They are, from left to right, Beverly Martin, Neita Cate, Flory Cavin, and Carolynn Lyman. The schedule of events on May 29, 1952, kicked off with tours beginning at 7:00 a.m., carnival rides, and a square dance festival from 7:30 p.m. to midnight.

BEANS ARE BEST. Pinto beans at the Moses Lake Development Farm (show here) produced about 30 pods to a vine, each pod containing from four to seven beans. In 1954, dry beans promised to be the most important crop in the Columbia Basin Irrigation Project area. Of the over 70 different crops planted in the project, wheat, sugar beets, and field corn followed closely in production expectations.

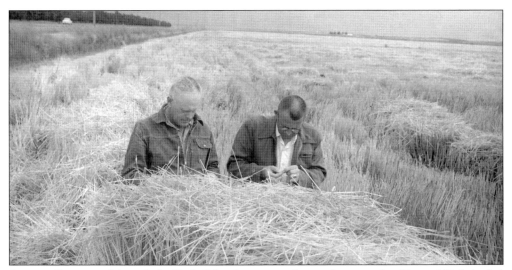

SETTING RECORDS. Moses Lake High School vocational agriculture teacher Howard York (right) and farmer Lee Holman kneel to examine wheat stubble on Holman's Block 42 farm. The field produced 110 bushels of Burt winter wheat per acre, one of the highest, if not the highest, yield ever reported in the basin prior to 1960. In past years, the field had produced potatoes, sugar beets, and sweet corn.

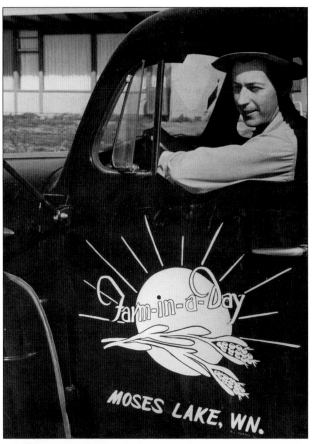

A Model Farm. The small family farm model envisioned by early proponents of the Columbia Basin Irrigation Project was predicated on Depression-era technology. By the time irrigation water became available, highly mechanized industrial farming was edging out the family model. The average necessary capital outlay for a 1950s-era operation—exclusive of the cost of the land—ran from $15,000 to $20,000. The average family income in the United States in 1952 was $3,900. The original allotment per farm unit was only 80 acres for a husband and wife. To overcome these shortcomings, early Block 40 farmers traded work, exchanged equipment, and banded together to tackle their problems. "I sure hope we can keep on hanging together and getting things done the way we have," said Emron Wright, president of the Block 40 Club in 1953.

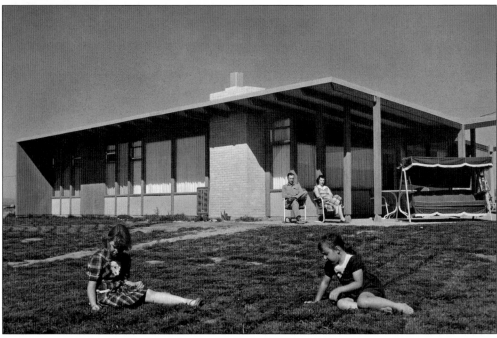

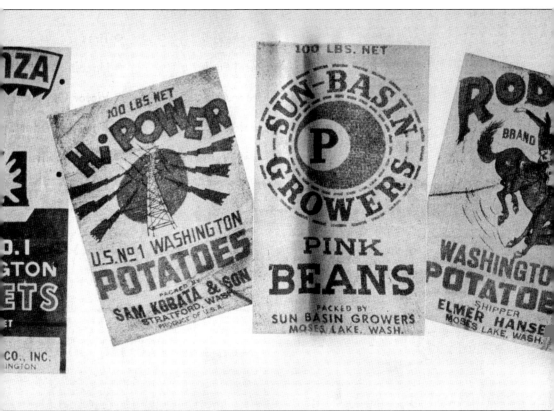

To Market. By 1963, produce from Moses Lake was shipped to markets throughout the United States and to foreign countries. The bulk of those crops were processed in local processing plants. Twelve different processing companies were represented in the Moses Lake-Strafford area: Utah-Idaho Sugar Company, Circle L Potatoes, Howard Michaelis Company, Menan Starch Company Inc., Columbia Bean & Produce Company Inc., Lovins Produce Company, Arden Farms Company, Basin Produce Company Inc., Sam Kobata & Son, Sun Basin Growers, Elmer Hansen Shippers, and the Harry Matso Produce Company. The Howard Michaelis firm grew and shipped potatoes for the potato chip industry. Shipments were sent to Portland, Oregon, for Blue Bell and to the Midwest for Fritos. A shipment of Gold Chip seed was sent to England.

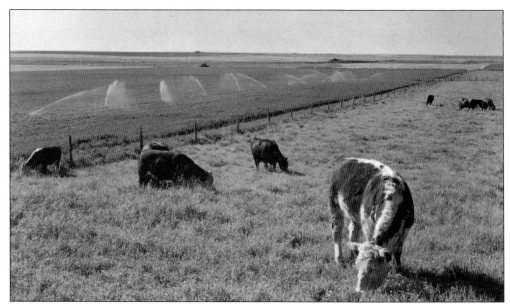

LIVESTOCK. Many well-rounded Moses Lake area farmers keep livestock like sheep, and beef and dairy cattle. Sheep and beef cattle thrived on readily available dried beet pulp produced by the Utah-Idaho Sugar Company refinery. Others prefer to feed their stock with readily available alfalfa silage. Silage is a high-moisture fodder created by fermenting cut green vegetation in silos.

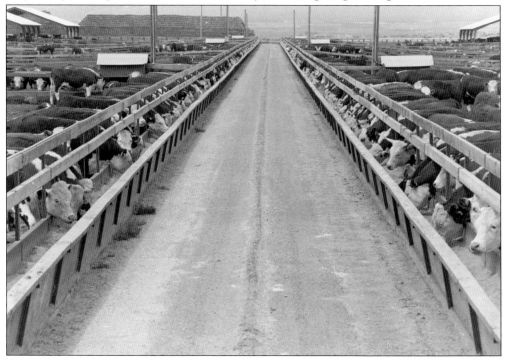

FROM A TO BEEF. In 1958, Allen and Wilma Sircin established the A&W Feed Lot in Moses Lake. That year, work crews began construction of a 2,000-head-capacity feedlot, including 2,900 feet of feed trough. The feedlot meshed with the growing potato industry in Moses Lake, using potato by-products as cattle feed. Fourteen years later, the couple sold their operation to Agri Beef.

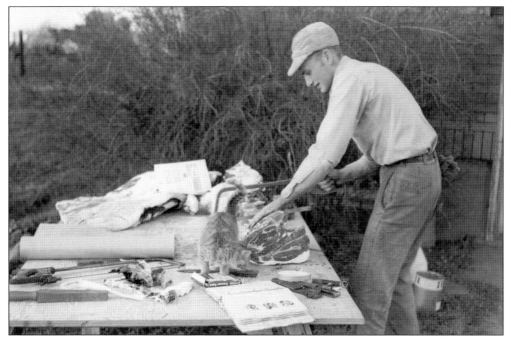

NAUGHTY ELMER. Farm cat Elmer supervises the "country-style" meat-cutting process on the Schiffner Farm about 1953. Today, most butchers and supermarkets receive their prime cuts from a slaughterhouse. Secondary cuts, like this rib roast, are prepared to order or sold prepackaged. Cattle fed a diet high in carbohydrates produce well-marbled cuts of meat.

A SWEET TREAT. A bowl of ice cream is a welcome reward any time of year in the Schiffner farmhouse kitchen in 1953. The Moses Lake Arden Farms milk-bottling plant reported in 1960 that Columbia Basin dairy would replace its Midwest sources of powdered milk for producing ice cream, remedying a shortage in the Northwest and Hawaii.

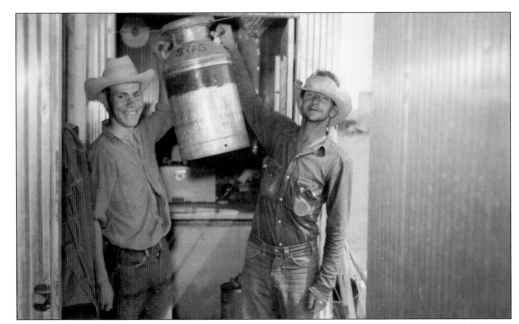

LIQUID GOLD. Farmhands David (left) and Harry load milk cans onto a covered truck at the Schiffner Farm about 1955. The number 505 on the can identified the milk's source when it reached the Carnation Milk center before shipment to Spokane for processing. Early economic advantages of milk production in the basin included easy access to forage crops and the rapid build-up of modern dairy processing.

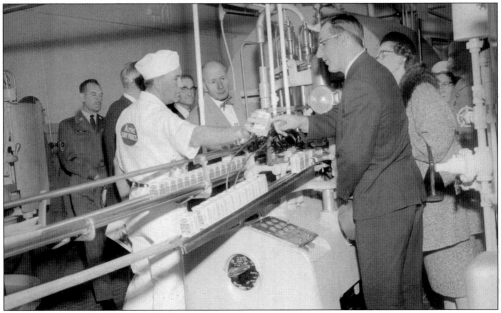

NEW PLANT TO AID FARMERS. An estimated 5,000 people toured the $1-million Arden Farms milk-bottling plant in Moses Lake on December 11, 1960. The bottling plant expanded opportunities for dairy farmers in Columbia Basin, and fluid milk and butter distribution throughout Eastern Washington. The Moses Lake Elks Club hosted a pre-tour luncheon for industry leaders, civic leaders, and officials from Larson Air Force Base.

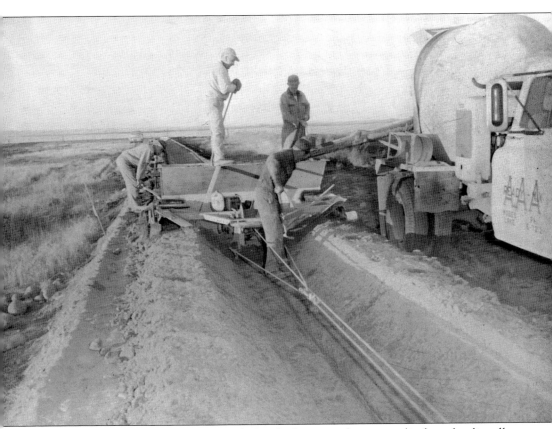

SOLID INNOVATION. Block 42 farmer Kenneth Goodrich invented a custom slip-form that literally forced him into the commercial ditch-lining business. Once water from the Columbia Basin Irrigation Project was received at each unit, it became the farmer's responsibility to control the water use. From the beginning, Goodrich and others had trouble controlling water in their head ditches and regulating the flow into the individual furrows. The Bureau of Reclamation had used concrete to line the ditches and canals of the irrigation project. Ken reasoned that permanent concrete linings would benefit farmers as well. The Soil Conservation Service agreed that concrete linings were a good conservation practice and became eligible for federal aid. In 1955, Goodrich developed a wooden slip-form. There was nothing like it in the local market, and after several remodels, Kenneth loaned the liner out to neighbors and friends. Goodrich was eventually spending 30 days out of the pre-season lining ditches. By 1988, he had lined over 1.5 million feet of irrigation ditches, the equivalent of 285 miles.

BEETS BRING BRACEROS BACK. The federal government transported thousands of Mexican nationals, known as braceros, to Washington to fill the World War II labor shortage. When the labor program ended, the Columbia Basin growers associations organized to bring the braceros back. Labor deposits totaling $8,000 brought 180 Mexican laborers to Moses Lake in May 1950. The opening of the Utah-Idaho Sugar Plant in Moses Lake (below) and a dramatic increase in acres dedicated to sugar beets brought a substantial migration of additional Mexican workers. Moses Lake merchants donated money, merchandise, and equipment to outfit this summer camp (above) for migrant farm laborers, reported community migrant committee chairman Dr. Robert Ruby in 1960. Don Hollingbery is on the tractor, and Frank Holmes drives the scoop. Many Mexican Americans stayed to make Moses Lake their home when the sugar plant closed in the late 1970s.

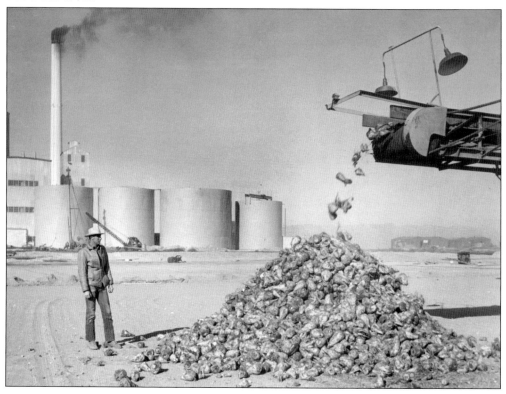

HIGH YIELDS. In 1953, the Utah-Idaho Sugar Company refinery began producing sugar in Moses Lake. The refinery operated from harvest in late September until February or March. By 1954, the plant was processing more than 2,800 tons of beets per day. Later expansion increased capacity to 6,250 tons. It is estimated the plant employed about 125 people when it opened, and 450 by 1979. Many farmers filled the processing jobs where they would work an eight-hour shift and then go home and work on the farm. In 1963, it was estimated that the U&I plant produced enough sugar to provide a 100-pound bag for every man, woman, and child in Washington State. Competition from overseas growers, depressed sugar prices, and cheap corn syrup production forced the plant out of business in 1979.

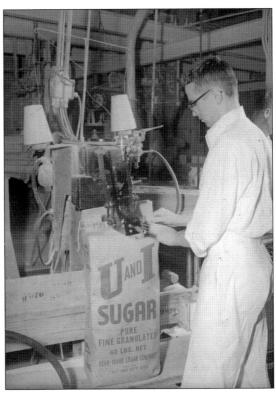

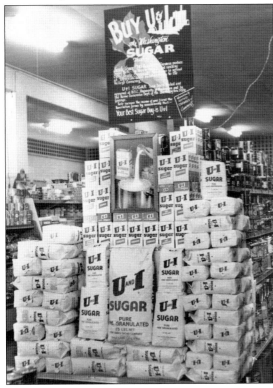

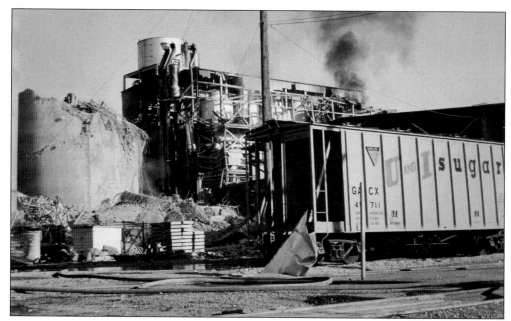

MASSIVE BLAST. A fire in a sugar bin set off a series of massive explosions that ripped through concrete storage silos at the Utah-Idaho Sugar Company at Moses Lake on September 25, 1963. Seven men were killed, and seven others were injured in the blast. More than 200 rescuers, most of them from nearby Larson Air Force Base, worked through the night by floodlight in search of the missing men.

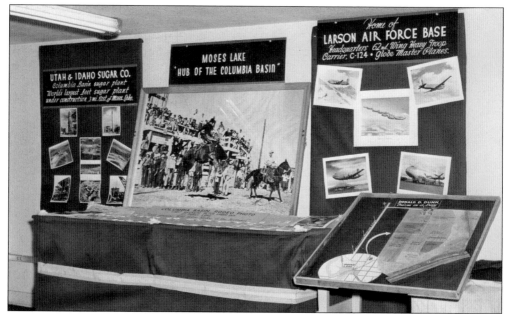

TRIPLE THREAT. This chamber of commerce booth displays the growing triad of agriculture, air power, and tourism all intersecting in Moses Lake about 1953. Ultimately, agriculture outpaced its growing contemporaries. By 1969, almost three fifths of all Grant County land was engaged in agriculture, and the food processing industry expanded to fill the void left at the end of an almost quarter-century-long Air Force presence in Moses Lake.

Three

THE SKY IS THE LIMIT

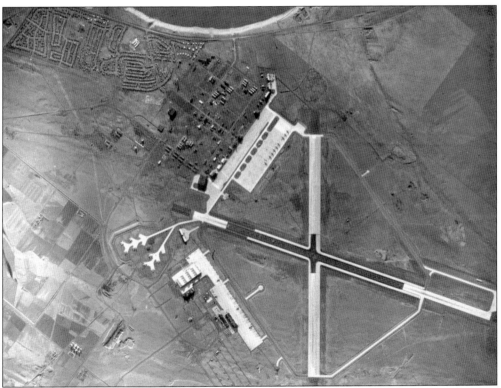

ESCAPING FATE. The air base and irrigation water brought unprecedented growth to Moses Lake at a time when many early Columbia Basin communities disappeared from the map. Activity at the air base brought hundreds of airmen and their families from across the nation. The population of Moses Lake grew from 326 in 1940 to 2,679 in 1950. After the arrival of the Air Force and irrigation water, the town population quadrupled.

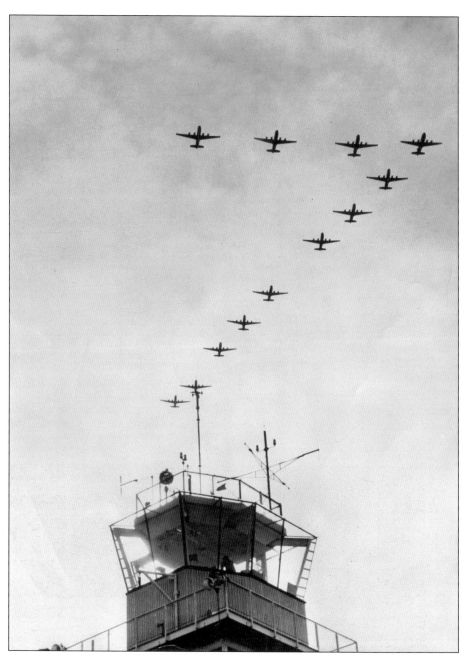

AIR BASE ACTIVATES, 1942. Eight months after Pearl Harbor, three new bases were approved—Clovis, New Mexico; Salina, Kansas; and Moses Lake, Washington. "The Government, at the beginning of World War II, was looking for inland aviation bases. A favorable site was chosen near Moses Lake and without a moment's notice several hundred construction men were moved in to build one of the largest of bases," wrote Loren Harris, Moses Lake postmaster. Moses Lake Army Air Base was activated to train B-17 combat crews and P-38 pilots. The base was hastily thrown together in six months, and the first troops were moved in from Walla Walla. Lt. Col. Jack R. Adams, a veteran of World War I, was the first commanding officer. Scenes similar to this formation of C-124 Globemasters became common in the skies over Moses Lake.

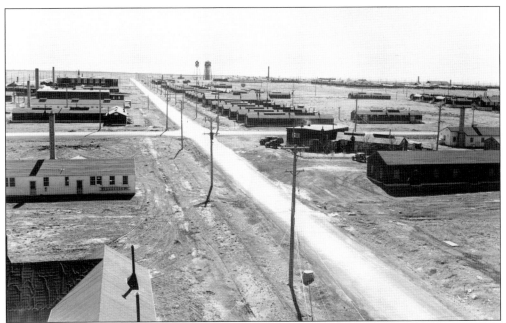

No Luxuries. The air base experienced natural growing pains. Isolation compounded the problems created by shortages of supplies, services, and officers. Rapid growth caused a major housing shortage in Moses Lake. Temporary developments were built, and housing was moved from outlying towns to help alleviate the deficit. "GI's would come and knock on our door and ask if they could rent a room," recalled Marjorie Ebel of Moses Lake. Winters were tough, and the overtaxed coal-fired heaters tried vainly to heat the flimsy barracks, below. In 1945, the Moses Lake Army Air Base was curtailed to standby status. However, the base continued to play a vital role in the US Air Force as a test site for two famous bombers, the B-47 Stratojet and the B-50 Superfortress.

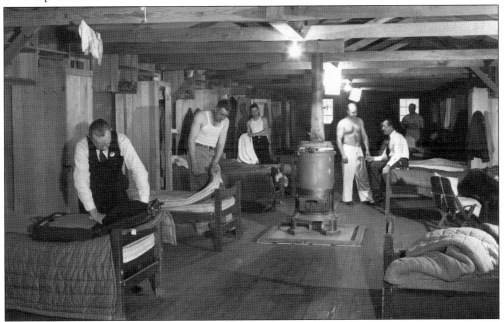

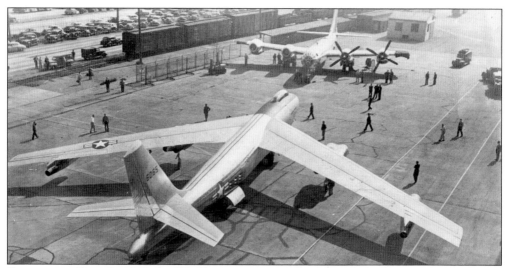

SETTING THE PACE. In 1947, the XB-47 prototype arrived at Moses Lake for crucial tests after its maiden flight from Boeing Field in Seattle. Two years later, the B-47 smashed the cross-country speed record, taking off from Moses Lake and landing at Andrews Air Force Base in Maryland in a mere 3 hours and 45 minutes. This photograph documents the XB-47's first public display at Boeing Field on September 13, 1947.

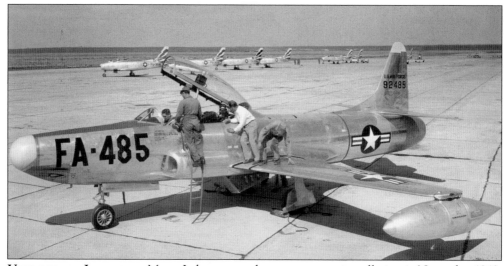

VIGILANT AND INVINCIBLE. Moses Lake reopened as a permanent installation in November 1948, under the Air Defense Command. Col. Harold E. Kofahi brought the 325th Fighter Wing and three squadrons of F-82 Twin Mustangs. In 1950, the first jet fighters, the F-86 Sabrejets and F-94 Starfires (pictured), moved in to protect the vital Hanford atomic works, Grand Coulee Dam, and other strategic points against enemy attack.

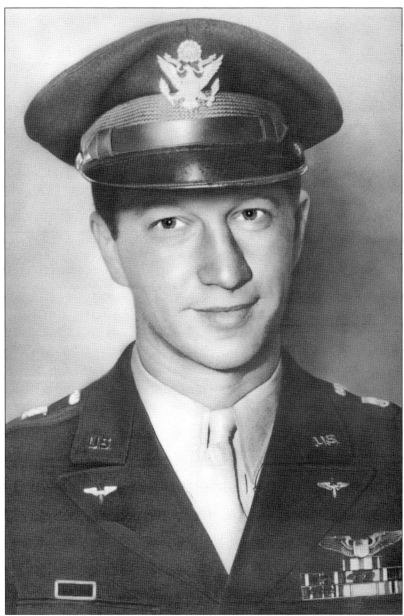

FLYING ACE HONORED. In 1950, the Moses Lake Army Air Base was renamed in honor of World War II flying ace Maj. Donald A. Larson of Yakima, Washington. Before enlisting, Larson was a reporter and photographer for the *Yakima Herald*. In 1941, he enlisted as a flying cadet at McChord Field, Tacoma. He attended flight training in California and went overseas in 1944. Larson flew a total of 57 combat missions over Berlin as a squadron commander in the 505th Fighter Squadron and is credited with destroying 11 enemy aircraft. He was killed in combat when his P-51 Mustang was shot down and crashed near Ulzen, Germany. He is buried at Ardennes American Cemetery in Belgium. He was 29 years old. Larson's medals and decorations include the Silver Star, Distinguished Flying Cross with Oak Leaf Cluster, Air Medal with three clusters, Purple Heart, American Defense Ribbon, European Theater Ribbon with two Bronze Stars, American Theater Ribbon, and Victory Medal.

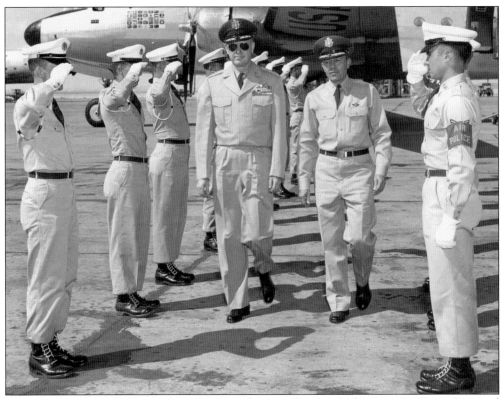

IN COMMAND. In 1952, Tactical Air Command assumed control of Larson Air Force Base and the 62nd Troop Carrier Wing moved in from McChord Air Force Base with its C-124 transports. The bases' first general officer, Brig. Gen. Harold W. Bowman, arrived along with the 62nd. In 1957, base commander Gen. Otto P. Weyland (pictured) announced that jurisdiction would shift from Tactical Air Command to the Military Air Transport Service.

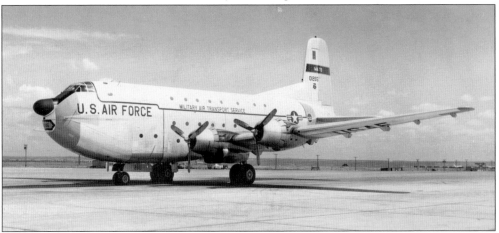

BEHEMOTH. The arrival of the Tactical Air Command brought the enormous C-124 Globemaster to Larson Air Force Base in 1952. The largest of the troop and cargo carrier aircraft, it was known by many nicknames, including "The Flying Freight Train" and "The Aluminum Cloud." During the stay of the 62nd, the main landing strip, originally built to 10,000 feet, was extended to 12,000 feet.

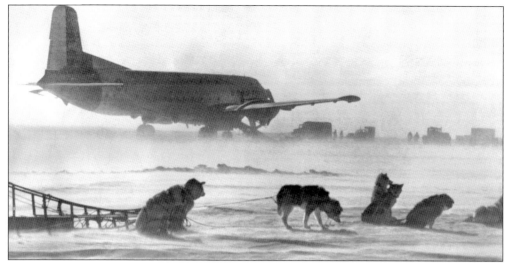

WORLDWIDE RESPONSIBILITY. Globemasters were prominent in the news, in such missions as the construction of the Distant Early Warning Line in the Arctic, providing airlift support in the Far East and Southeast Asia, and numerous mercy flights across the globe following floods and other natural disasters. The Distant Early Warning Line was a system of radar stations across the Arctic used to detect and warn against threats of invasion by Soviet bombers. Men from Larson Air Force Base unloaded welcomed supplies from a C-124 Globemaster at an isolated ice strip 250 miles from the Arctic Circle. Shown here on April 12, 1956, Larson's base aircraft delivered equipment to the far north radar station beginning in early February of that year. Runways were carved from the ice for the giant aircraft. A dogsled team stands ready to retrieve the latest shipment.

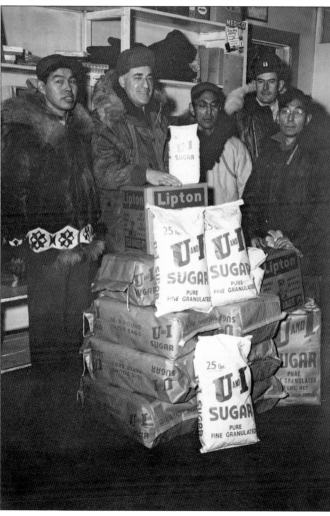

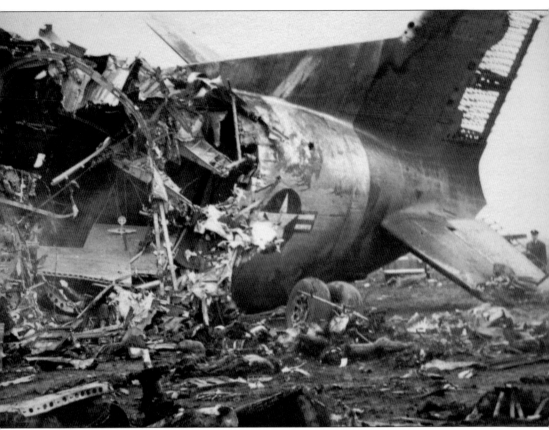

HOLIDAY TRAGEDY. On the cold winter morning of December 20, 1952, some 115 soldiers and crew members on their way home for the Christmas holiday were on board a C-124 Globemaster as it slowly lumbered down the Larson Air Force Base runway en route to Texas. Near the end of the runway, the plane went into a steep climb. Unable to level out, it began to stall, and the aircraft's left wingtip struck the ground. Survivors recounted the feeling of helplessness as the aircraft shuddered and then slammed into the hard desert floor, igniting thousands of gallons of high-octane gasoline. Within seconds, the aircraft was reduced to a twisted wreck of metal and shredded debris. Rescue crews were primarily assigned the grim chore of recovering the 87 dead. At the time, it was the worst tragedy in military air history.

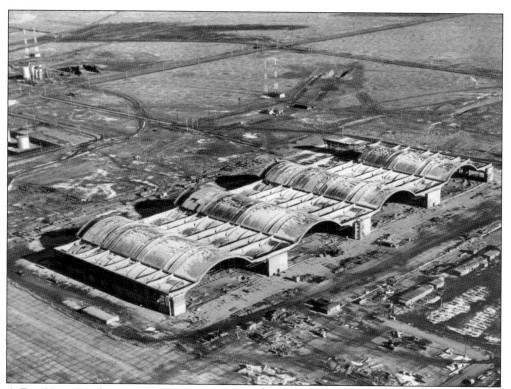

A Big Nest. Look again, this is not a giant roller coaster, it is the eight-place hangar for the new Boeing B-52, then under construction at the Boeing Flight Test Center. The B-52 bombers began partial tenancy in the huge new hangars in August 1957. The Boeing Flight Test Center operated from 1955 to 1962.

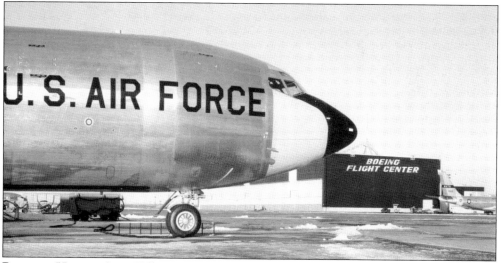

Boeing is Here to Stay. Following rumors of a closure at the Boeing Flight Test Center, Larson Air Force Base officials announced a contract extension for the modification of KC-135 tankers in 1960. After the center closed in 1962, Boeing purchased 130 acres at the Moses Lake Airport in 1968 as part of its flight-training program. Flight tests of the Boeing 747-8 Freighter and 787 Dreamliner began in 2010.

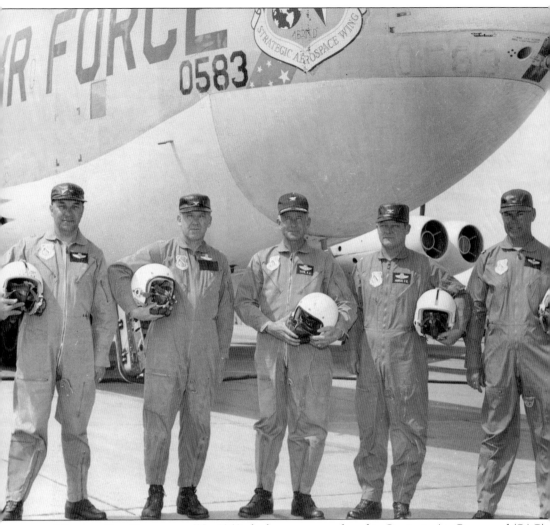

"PEACE IS OUR PROFESSION." In 1960, the base was transferred to Strategic Air Command (SAC) and the 4170th Strategic Wing moved to Moses Lake. SAC's defense installations at Larson included the B-52, KC-135, and the Titan I intercontinental ballistic missile. SAC was in charge of the nation's nuclear forces from 1946 to 1992. The wing's first B-52D Stratofortress to arrive at the base was christened *Larson's Lucky Lady*. The B-52D was specially modified to increase bomb capacity and to accommodate aerial refueling. The first KC-135 Stratotanker arrived with the 43rd Air Refueling Squadron at Larson in 1961. The squadron provided high-speed aerial refueling support.

ON CALL. Larson's B-52s were engaged in 24-hour alert duty. Strategic Air Command's strike force had aircraft, bombs, and crews ready for counterattack within minutes after any aggression against the United States. The base B-52 "Sunday Punch" stood ready to conduct long-range bombardment operations using either nuclear or conventional weapons.

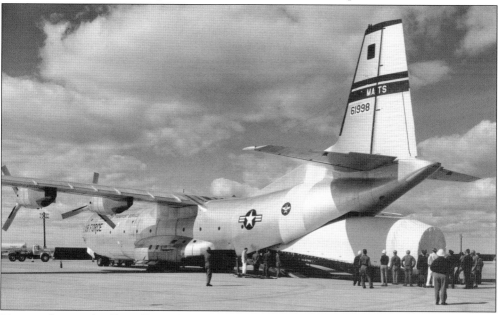

TITANIC. Larson Air Force Base's Titan I intercontinental ballistic missile capabilities began in 1961 when three launching complexes, each outfitted with three nuclear missiles, were installed near Royal City, Warden, and Odessa. Here, a C-124 delivers a concealed section of a Titan I missile. A heavy guard of Air Police, state patrolmen, sheriff's officers, and city police escorted the truck convoy to the build site.

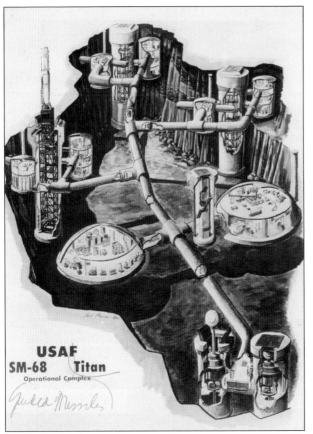

USAF
SM-68 Titan
Operational Complex

THE UNDERGROUND. Six missile squadrons were outfitted with Titan Is in Washington, Idaho, Colorado, South Dakota, and California between 1960 and 1965. The Titan program was part of the United States' twofold defense system operating parallel to 11 squadrons of Atlas missiles. Each Titan missile complex was reminiscent of a science-fiction alien city. Operating crews stood ready to retaliate against an act of nuclear war or launch a preemptive strike. Over half a mile of underground passageways connected the 150-foot-deep launch silos. Each complex could support a complement of 150 men for up to 30 days. The 400-pound silo doors were capable of withstanding a nuclear blast up to 3,000 feet away. Nine Atlas missiles near Fairchild Air Force Base in Spokane made Eastern Washington one of the most heavily armed sections of the country.

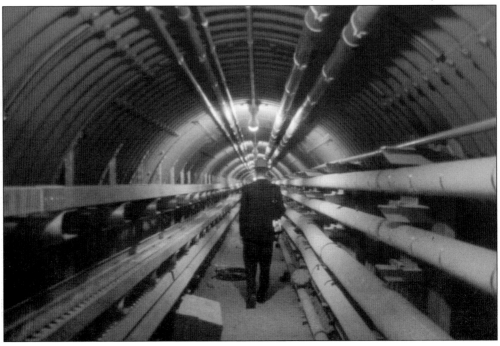

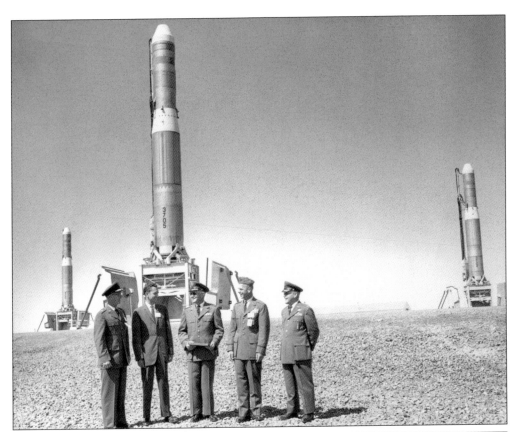

CRISIS. The Larson Titan I complex became operational nine months before reconnaissance revealed Soviet missiles under construction in Cuba. On October 27, 1962, the 13-day Cuban Missile Crisis concluded when an agreement was reached for the removal of US missiles in Turkey in exchange for the removal of the Cuban missiles. The squadron stood poised for three years until the Defense Department announced the elimination of the Titan program in 1964.

PAYLOAD. The Titan I was a liquid-fueled missile produced by the Martin Company. Missiles were stored in underground silos and raised on an enormous elevator system for launch. Separation from the first-stage booster and a second-stage engine ignition gave Titan I an effective range of 5,500 nautical miles. Each warhead contained a W38 thermonuclear bomb with a yield of 3.75 megatons, 250 times that of "Little Boy," detonated over Hiroshima.

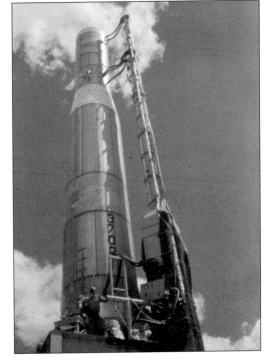

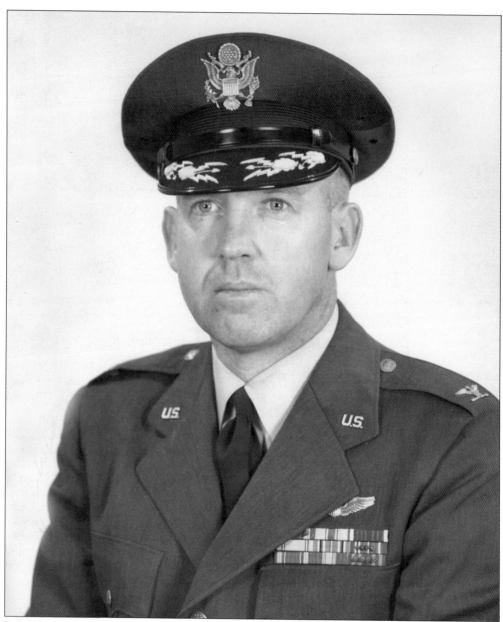

LAST COMMANDER. Col. Clyde Owen arrived at Larson Air Force Base in 1963 to accept the assignment of base command. He is probably most well known for his role in orchestrating the base's closure, announced in 1964 and finalized in 1966. When Owen made the official announcement of the base closure to Moses Lake on November 24, 1964, he was keenly aware of the effect it would have on the community. The total base population was an estimated 7,000. Community members formed the Larson Action Committee under the leadership of Big Bend Community College president Al Phillips. The group put together a proposal for a port district that was approved on the 1965 ballot. Following the base closure, Owen was offered the new port manager position, marking the end of 26 years of active duty. Over the course of his career, Owen logged 5,300 hours flying time and flew 43 combat missions. He is the recipient of the Air Medal, Purple Heart, Commendation Medal, as well as other World War II decorations.

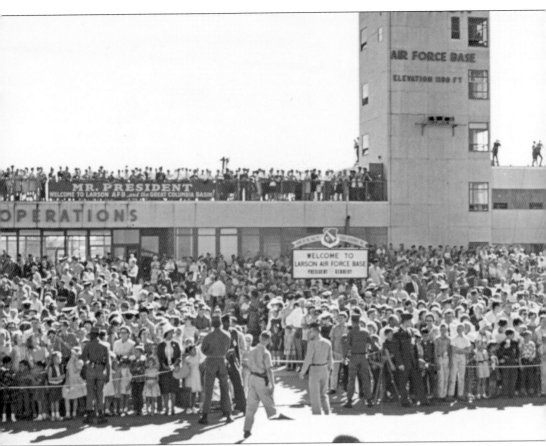

WELCOME, MR. PRESIDENT. Four US presidents have visited the Columbia Basin region. Franklin D. Roosevelt visited the Grand Coulee Dam construction site in 1934 and 1937. Harry S. Truman dedicated the reservoir behind the dam in 1950, naming it Franklin D. Roosevelt Lake. When he was still secretary of commerce, Herbert C. Hoover toured the arid lands of the proposed Columbia Basin Irrigation Project in 1927. On September 18, 1963, the morning after the disastrous Utah-Idaho Sugar Plant explosion, Pres. John F. Kennedy landed at Larson Air Force Base. He was en route to commemorate the last of Hanford's nine plutonium production reactors, the N Reactor, and break ground on the facility's power plant. More than 5,000 people gathered at the runway to watch the arrival of Air Force One in Moses Lake. The president was only scheduled to be on the ground for five minutes and then depart by helicopter for the ceremonies at the Hanford Site.

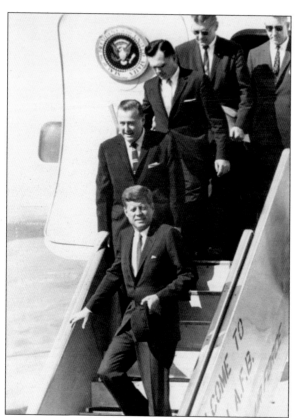

GREETING THE CHIEF.
Accompanying President Kennedy (bottom of stairs) on his brief stop were US senator Warren G. Magnuson and Secretary of the Interior Stewart L. Udall. Base commander Col. Clyde Owen recalled Secret Service agents overrunning the base for 10 days prior preparing for the visit. Greeting the party were US senator Henry M. Jackson, Gov. Albert D. Rosellini, Dr. Gerald Tape of the Atomic Energy Commission, from Fairchild, and Larson Air Force Base officers Col. Clyde Owen, Col. David A. Tate, Maj. Gen. William C. Kingsbury, Col. R.B. Templeton, and area residents Harvey D. Vernier, Henry J. Boyle, James H. Tyson, Leon M. Bodie, H.E. Snead, and Ned Thomas, all of Moses Lake, State senator Nat Washington, State representative Roy Mundy, William E. Rawlings, Gordon Nicks, and Selma Therriault of Ephrata, and Robert A. Ludolph of Grand Coulee.

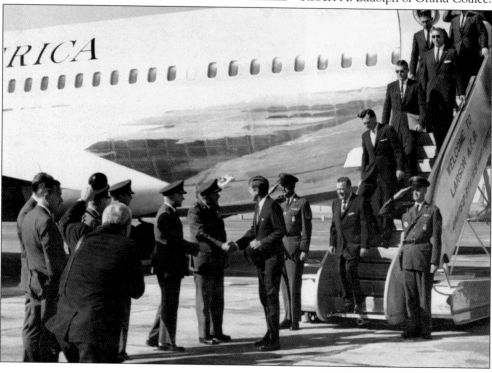

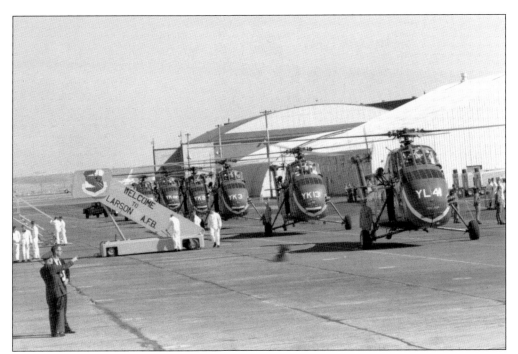

ENTOURAGE. In total, three airplanes and nine helicopters completed the outfit involved in transporting the president and his entourage. His personal aircraft was a beefed-up Boeing 707. Its twin followed as a backup. A third aircraft, a Pan American 707, carried 40 members of the press. The press contingent was shuttled to the Hanford site on five UH-34 helicopters, with a sixth in reserve.

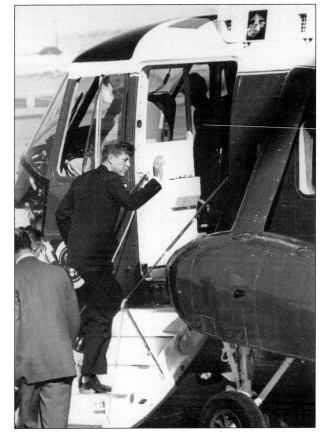

SAYING GOODBYE. Three Marine Corps VH-3A helicopters stood awaiting touchdown to carry the president to the Hanford Site, where relaxed safety restrictions would assemble a crowd of more than 30,000. President Kennedy's visit to Moses Lake and the Columbia Basin took place just four months before he was assassinated in Dallas, Texas.

SOCIAL HUB. The Noncommissioned Officer's Open Mess (NCO) at Larson Air Force Base was open to the top five grades and airmen first class with over four years of service. The club featured a ballroom, cocktail lounge, dining room, outdoor patio, and numerous other amenities for hosting events like this special reception for incoming commander Col. Mickey McGuire in 1954.

FAMILY LIFE. Family housing made Larson Air Force Base a community as well as a modern air base. Permanent base housing for families was developed beginning in 1951 with the completion of 400 units and expansion to some 1,330 units. Here, Maj. Wayne D. Waller and family pose for a portrait session with Moses Lake photographer William R. Hilderbrand. The temporary Victory Village housing in downtown's McCosh Park was removed in 1959.

SELF CONTAINED. The base offered every imaginable amenity, making it fully self-sufficient. A hospital, bank, newspaper, chapel, library, beauty salon, and even a bowling alley made trips on the shuttle into nearby Moses Lake practically unnecessary. The base even maintained its own exclusive recreational and boat facilities at Airmen's Beach, less than a mile away. The theater offered two continuous shows seven days a week and weekend matinees.

MAKING DUE. Larson Air Force Base barracks were utilized as classrooms as Moses Lake schools began to overflow in 1954. The old barracks were upgraded by replacing aging coal heaters with oil and partitioning the latrines. The Moses Lake School District reported that when the school year began, there were 3,318 pupils enrolled. By December, the number had increased to 3,487, with another 200 expected before year's end. (Photograph courtesy of Harold Hochstatter.)

SPIRIT SHOWN. Moses Lake recognized that its economy was based on agriculture, and fears of the 1966 Larson Air Force Base closure were largely unfounded. Civic leaders admitted there were bound to be changes, but overall the facilities left behind would hold future promise for the town. Moses Lake Mayor Harold Stadshaug said, "This town isn't going to die." Moses Lake was home to the air base for 24 years.

LIFE AFTER LARSON. The Columbia Basin Job Corps Center moved to facilities on the air base, and Japan Air Lines moved in, as did the Big Bend Community College. These changes helped Moses Lake pull through the nearly decade-long economic slump following the closure of Larson Air Force Base in 1966. Here, base commander Col. Clyde Owen presents a gift to deputy commander for maintenance Col. Bob Mullins at the base closure party.

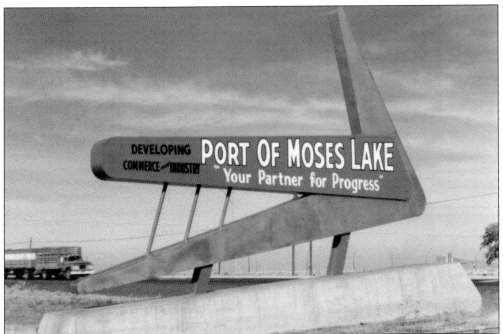

PORT FORMS. The Port of Moses Lake was approved by a landslide vote in 1965, and the district suddenly found itself in possession of one of the longest civilian runways in the United States. Boeing announced its plans to house its pilot-training program at Moses Lake. Big Bend Community College also moved its aviation program to the port district. (Photograph courtesy of the Port of Moses Lake.)

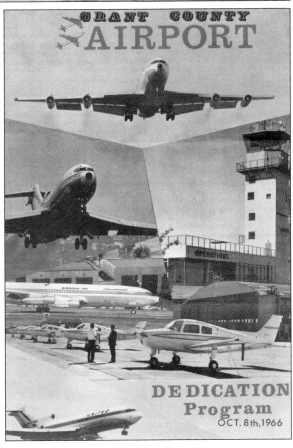

INTERNATIONAL AIRPORT. The Port of Moses Lake dedicated the Grant County Airport before a crowd of 3,500 with a series of ceremonies and flight demonstrations on October 8, 1966. By 1968, the airport was handling 50,000 takeoffs and landings annually. That same year, Japan Air Lines moved its training programs to the airport. Many Moses Lake residents visited Japan through a sister city exchange on flights courtesy of the airline.

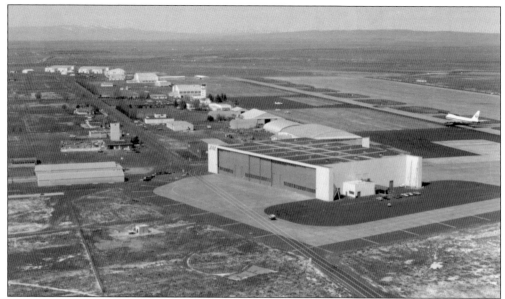

JAPAN WELCOMED. In 1968, Japan Air Lines moved its 747 training program from Hilo, Hawaii, to Moses Lake on a three-year contract. Moses Lake was chosen for its traffic-free air, good weather, and ample ground space. The airline leased a hanger near the terminal for use as an operations center and the former Bachelor Officers' Quarters building for trainee housing. (Photograph courtesy of the Port of Moses Lake.)

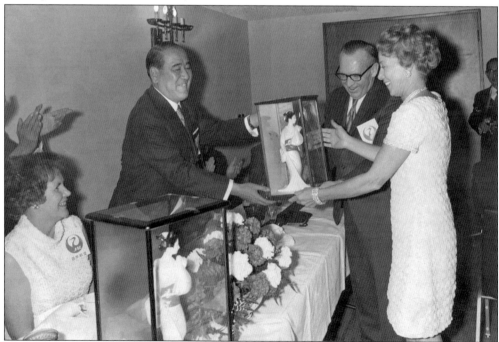

RISING SUN. Japan Air Lines contributed considerably to the economic and cultural wealth of Moses Lake. For more than 30 years, every Moses Lake sixth-grader was treated to a scenic flight over the town aboard a JAL aircraft. Here, Captain Odagari of Japan Air Lines presents a gift to Moses Lake Port manager Clyde Owen and his wife, Audrey, about 1969.

CORPS ACTIVATES. In 1965, the Bureau of Reclamation contacted Larson Air Force Base commander Col. Clyde Owen to discuss opening a 200-man Job Corps center on the soon-to-be-decommissioned base grounds. Later that same year, the Columbia Basin Job Corps opened a 20-acre facility, located in an administrative area of the 9,000-acre base. A 500-man mess hall was selected as the program's new headquarters in Moses Lake. The Job Corps program, created in 1964 by the Office of Economic Opportunity, was designed to give disadvantaged youth an opportunity to gain work experience performing conservation chores. The program was modeled on the Depression-era Civilian Conservation Corps. Initial work projects for the first year included work on trails, boat ramps, campsites, and similar projects in the Potholes Reservoir area. (Photographs courtesy of Columbia Basin Job Corps.)

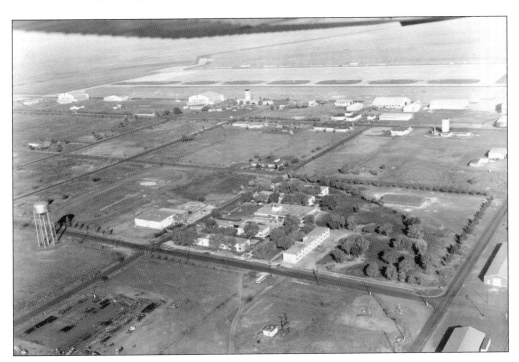

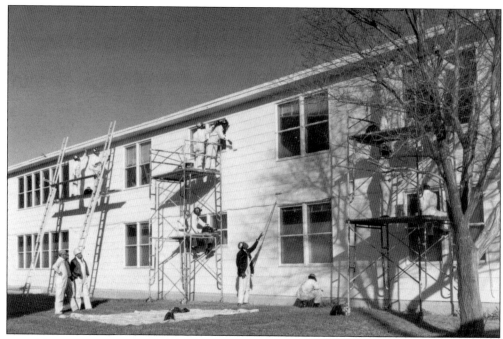

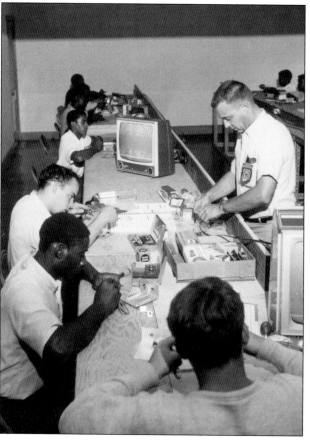

TRADING SPACES. Corpsmen learn a trade while attending educational classes at the Job Corps center. Corpsmen enrolled in the painting program learned various techniques (above), including erecting scaffolding and applying a new finish to the exterior of buildings. Upon successful completion of the painting curriculum at the center, corpsmen were placed in an apprenticeship in a painting union. Students solder under the tutoring of center instructor Richard Pitts (left) in vocational training class in elementary television repair. Today, the Columbia Basin Job Corps has almost 300 residential students and is open to both men and women. Students can choose from more than 100 trades, from pharmaceuticals to heavy equipment repair. (Photographs courtesy of the Columbia Basin Job Corps.)

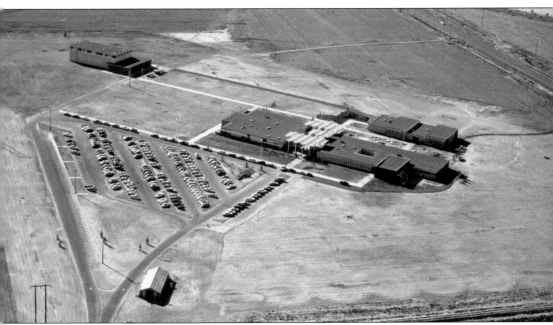

BIG BEND. Named for the "Big Bend Country" situated within the bend of the Columbia River, Big Bend Community College (BBCC) opened a 144-acre campus in Moses Lake in 1963 (shown here). In 1964, plans were announced to close Larson Air Force Base, and college president and head of the Larson Action Committee Dr. Alfred Phillips convinced authorities to gift a portion of the air base to the junior college. Six miles from the main campus, the new acreage became known as the "North Campus." In 1969, the board of trustees voted to move the entire operation to the North Campus. It took nearly a decade to complete the move to facilities on the former air base. The old base theater was one of the first buildings remodeled. In 1974, the first college musical at the theater guest starred Leonard Nimoy as Fagan in *Oliver!* The opening of the Advanced Technologies Education Center in 2005 and the Fine Arts Building in 2008 ushered in the next era for Big Bend Community College. (Photograph courtesy of Big Bend Community College.)

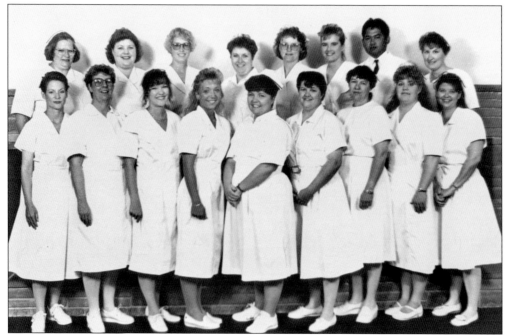

BBCC NURSING. Anticipating the needs of the fastest-growing community in the Columbia Basin, the health care community of Moses Lake petitioned the new junior college to implement a Practical Nursing Program in 1963. A satellite Associate Degree Nursing Program began in 1984. The college opened enrollment into its own Associate Degree Nursing Program in 2002. (Photograph courtesy of Big Bend Community College.)

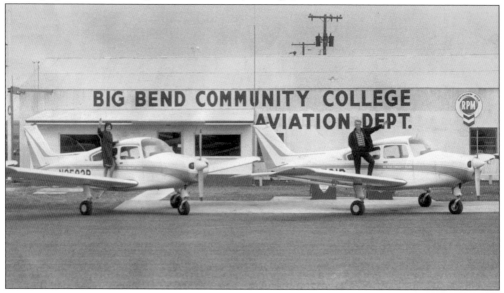

BBCC AVIATION. Big Bend Community College began its pilot-training program in 1965 with 23 students and three airplanes. The aviation program moved into the vacated Air Force hangers along with programs in aviation mechanics, welding, electronics, and automotive technology. Today, this Federal Aviation Administration–authorized flight program has up to 120 students enrolled, 25 aircraft, and three Frasca Simulators.

Three

SUN BASIN VACATIONLAND

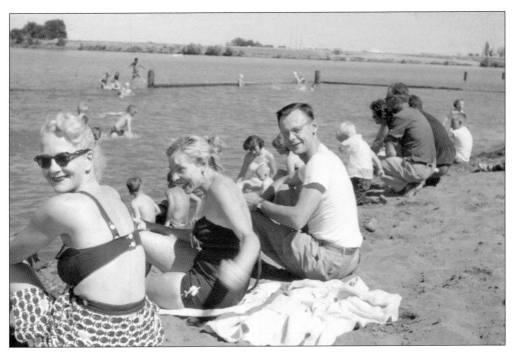

LAKESIDE LIFESTYLES. Fun in the sun is no cliché at Moses Lake, it is a reality for residents and visitors alike. Tourism campaigns advertised the lake's many amenities as the population grew. Numerous picnic areas, swimming beaches, and 120 miles of shoreline were just a few of the highlights that drew tourists to the Sun Basin Vacationland capital. The swimming beach at Moses Lake State Park is pictured here about 1960.

MOSES LAKE

WASHINGTON.

THE AGRICULTURAL METROPOLIS AND RECREATION PARADISE OF THE SUN BASIN

JUMP IN. A pleasant climate, low humidity, and long, clear sunny days make Moses Lake a vacation destination worthy of acclaim. Taking a plunge into the water is a must when temperatures reach into the 90s, with some days rising over 100 degrees in July and August. An early study of Moses Lake named agriculture and recreation as the city's two top potential opportunities for future growth. Expanding irrigable acres and maintaining the lake's many boat ramps and picnic facilities were stressed to cushion the blow that the closure of Larson Air Force Base dealt to Moses Lake in 1966. It seems that agriculture and recreation have always gone hand in hand in Moses Lake. In 1961, the Washington State Game Department reported that record numbers of pheasants were expected to swarm into the Columbia Basin. Several cooperative operators of Moses Lake's Block 42 farm units opened 7,000 acres to hunting for the event.

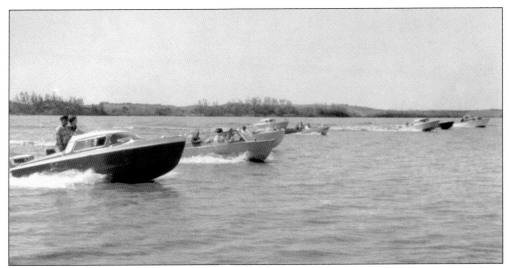

MANY BOATERS' PARADISE. Take 6,500 acres of water and throw in Moses Lake's many launching facilities, and the result is a recipe for a true boaters' paradise.

SPEED LIMIT FIVE MILES PER HOUR. Boaters navigate the waters under the center span of the Interstate 90 crossing between the Peninsula and Westlake to avoid the lines of eager fishermen that frequently line the bridge. Today, Moses Lake is open year-round to fishing for bass, bluegill, trout, black crappie, carp, channel catfish, yellow perch, and walleye.

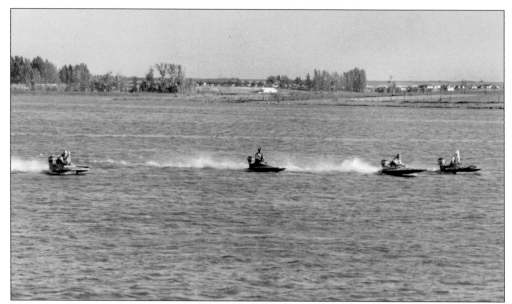

SPEEDSTERS' MECCA. As boating and water-skiing became more popular, hydroplane races took an early lead as one of Moses Lake's most prominent annual events. Spectators lined the shores of Cascade Park on Lewis Horn, one of the three main arms of the lake, which are each approximately 18 miles long and up to one mile wide.

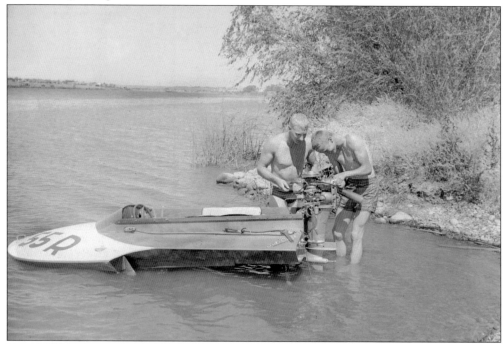

TUNING UP. Moses Lake racing phenoms, the Holmes brothers Bud (left) and Butch are shown here preparing for the District No. 10 hydroplane championships held July 10, 1960. The brothers are tuning up the motor of their B outboard hydroplane, which reached a maximum speed of 70 miles per hour. They took both firsts in the A and B stock hydroplane races on Moses Lake in 1958.

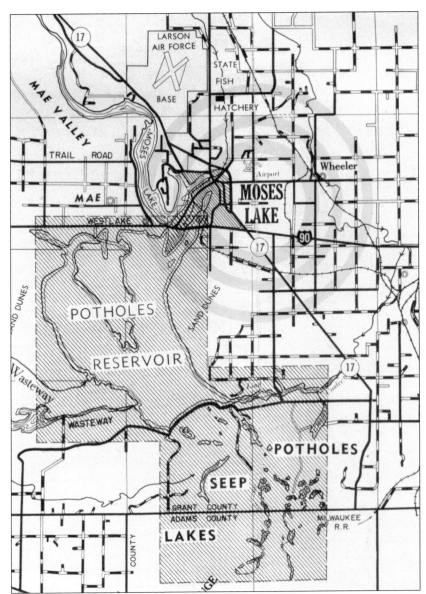

EXTENDED WATERWAYS. Moses Lake is part of a system of waterways that includes the Potholes Reservoir and Seep Lakes. The 19,000-foot earthen O'Sullivan Dam, built in 1949, was named for James O'Sullivan, a member of the Columbia River Development League instrumental in supporting Grand Coulee Dam and the Columbia Basin Irrigation Project. Located on the Crab Creek outlet to the south of Moses Lake, the dam created the 32,820-acre Potholes Reservoir, named for the nearly 800 small ponds and 1,000 islands scattered throughout the reservoir. The Potholes store wastewater from irrigated lands for reuse on downstream farmlands. The Seep Lakes, located to the south and reaching into Adams County, are a series of canyons and potholes, created by Ice Age floods, which have filled with water seeping in from the Potholes Reservoir. The Columbia Basin Irrigation Project altered the region's traditional shrub steppe vegetation, creating wetlands where once only big sagebrush and bunchgrass existed. New riparian areas provide excellent opportunity for hunting waterfowl. Gravel roads and boat launches offer access to an abundance of public fishing.

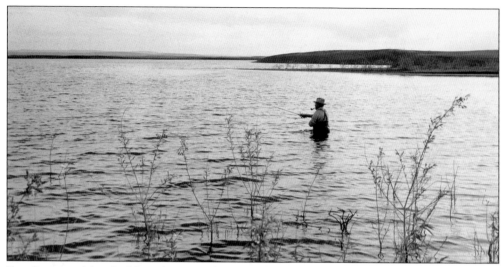

FISH STORIES. After the Neppel carp market waned, some families still ate them. Historian Helen Knapp said, "The current story was that you cleaned and prepared the carp and baked it on a board. When done, you threw the carp away and ate the board." Little attention was paid to game fish until 1927 when the Washington State Game Commission planted bass seined from the Pend Oreille River in Moses Lake.

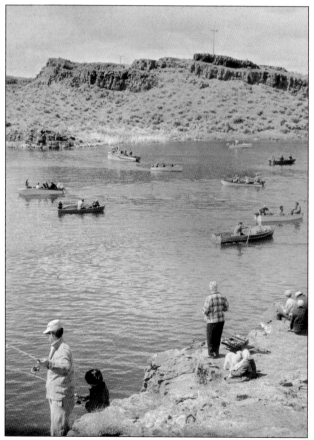

RUGGED AND REWARDING. Rain, cold, and even a little snow did little to hamper the turnout for the opening day of fishing season on April 24, 1960. Over 600 fishermen descended on Corral Lake, one of many seep lakes below O'Sullivan Dam, netting over 2,217 fish. It was estimated that approximately 12,000 people fished the extended Moses Lake waterways.

HUNTERS FLOCK TO BASIN.
As farmland developed in the
irrigated areas of the Columbia
Basin Irrigation Project, game
birds such as these pheasants
became more plentiful. Acres of
beets provided cover for more
than an estimated 150,000
pheasants. More and more hunters
from outside the area came to the
basin to sample the good hunting.
Two visiting hunters show off
the limit of six pheasants.

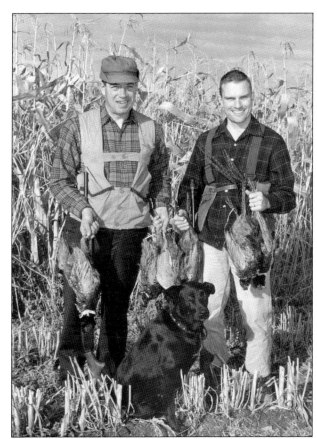

EXTRAORDINARY HONORS. Edwin
Sands of Moses Lake shows off his
prized stuffed Chinese ring-necked
pheasant that he planned to enter
in *Outdoor Life* magazine in 1960.
The bird was bagged between
Moses Lake and Marlin, and
stuffed by Ben Peterson of Moses
Lake. Sands was employed as a
mechanic at Boeing Flight Test
Center at Larson Air Force Base.

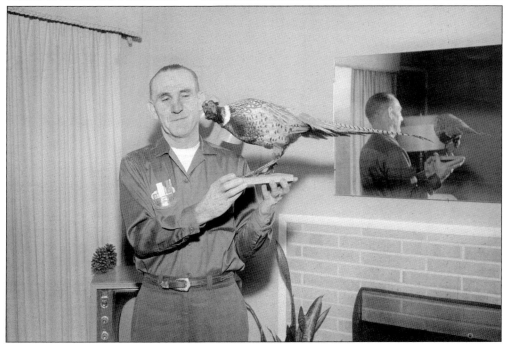

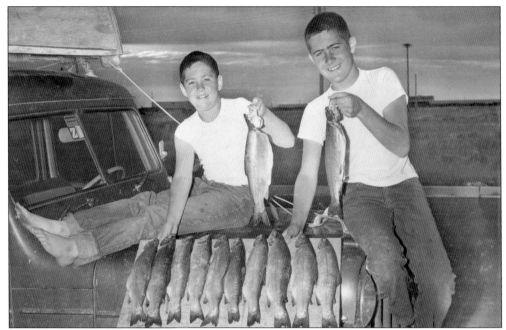

FIRST CLASS RECREATION. New arrivals to Larson Air Force Base in the early 1960s were issued a guide to the base, Moses Lake, and surrounding amenities. Many base families soon acquired their own boats and took to the Moses Lake waterways. These "small fries" with their "big fry" have just spent the day fishing at the Potholes Reservoir. Note the Boeing access pass in the car window.

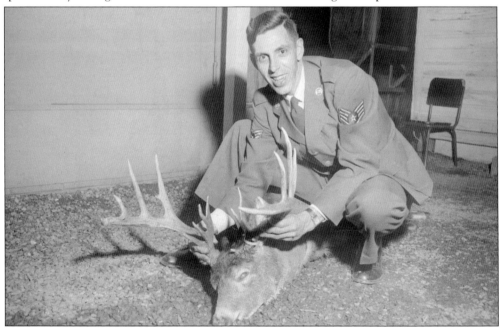

IMPRESSIVE SPREAD. Staff Sgt. Stanley Barber of Larson Air Force Base shows off the nine-point buck he shot near Hunter in Stevens County in 1957. A limited number of mule deer can be found nearby in canyons and scabland areas. Hunters seek permission to hunt primarily game birds on private lands in Moses Lake or visit the many acres of public lands near the Potholes Reservoir.

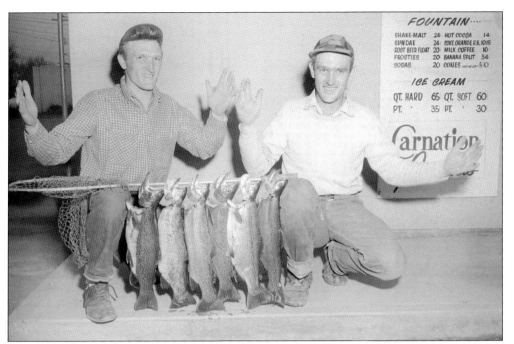

STOP WISHIN', GO FISHIN'. Brothers Tom Fuller (left) and Herbert Fuller of Moses Lake exhibit a winter catch of rainbow trout, each three to five pounds each, pulled from Morgan Lake in the Potholes seep lakes area on February 19, 1958. Today, Morgan Lake is only open to fishing April 1 through September 30.

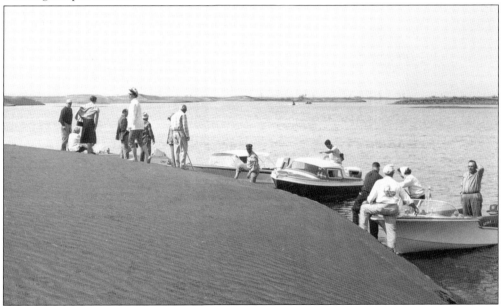

MINIATURE SAHARA. The Moses Lake Sand Dunes are a unique and fascinating area for recreation. Accessible by boat or car, the undulating desert of rolling sand dunes offers excellent boating and picnicking opportunities. Today, the Moses Lake Sand Dunes are popular with all-terrain vehicle enthusiasts. NASA tested its lunar vehicles at the dunes in June 2008, in anticipation of a return to the moon by 2020 to set up outposts.

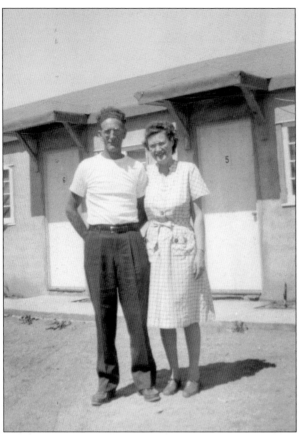

MANY AND MODERN. In 1946, business partners Earl Key, Jack Troyer and Judson Henderson built a motel in Moses Lake anticipating the growth of the Columbia Basin Irrigation Project. The Maples Motel grew one section at a time into a 55-unit motel. Earl and Hazel Key were the first proprietors. The motel's slogan was "For the 'Rest' of Your Life." Judson and Orlena Henderson (pictured) stayed in Moses Lake after selling their interest in the motel. Orelna became the secretary to Moses Lake School District superintendent Charles McFadden. All three partners eventually sold their interests in the Maples Motel to Earl 's brother, Eugene Key. By 1963, Moses Lake's 14 motels could provide accommodations for approximately 500 overnight visitors, in addition to meeting and convention facilities. The Maples Motel is now the Studio City Apartments at 1112 West Third Avenue.

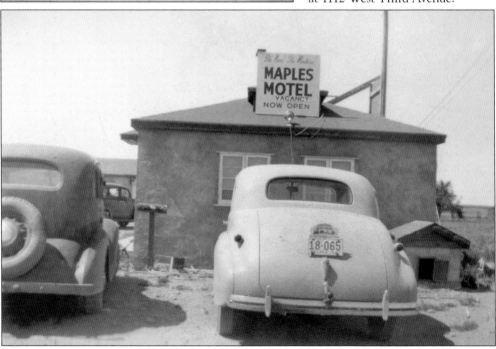

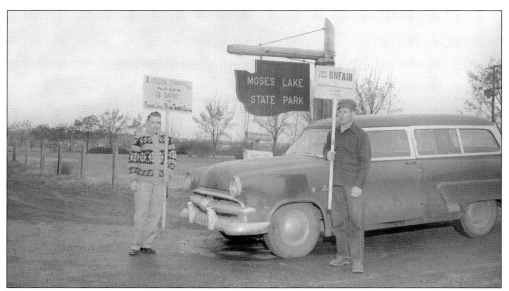

PARK PICKET. Elmer Inks, left, and Lawrence Bichler of the Steamfitters Local 820 in Moses Lake picketed in front of Moses Lake State Park on January 7, 1958 in a dispute over pipe fitting work being done on the park's sprinkler system. The former state park is now operated under the auspices of the City of Moses Lake Parks and Recreation Department as Blue Heron Park.

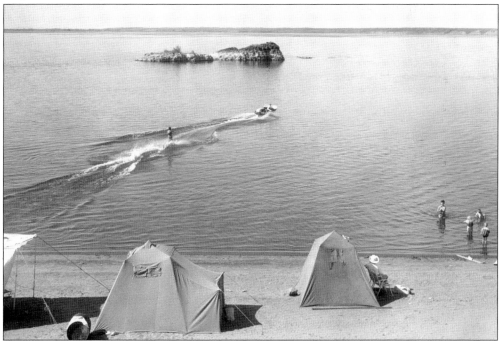

BASIN BY-PRODUCT. The massive Potholes Reservoir, originally created for irrigation and power production, became increasingly popular as a recreation hotspot. The Columbia Basin Irrigation Project, unlike some other reclamation projects, was not granted specific authorization to develop recreational features by Congress. Public lands within the project were turned over to federal and state agencies for recreational and wildlife administration. Management includes stocking game fish and upland game birds.

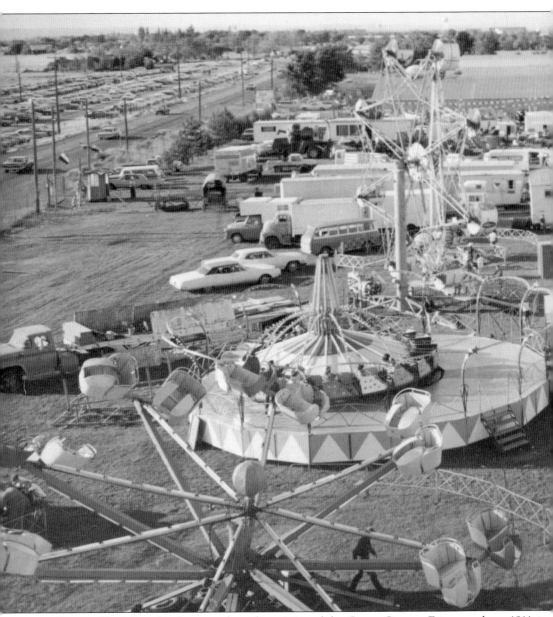

COUNTY FAIR. Local ephemera place the origins of the Grant County Fair as early as 1911 in Wilson Creek. The fair moved to Moses Lake around 1923. A handful of old-timers recalled the event was held downtown and was moved to its present location on Airway Drive in 1948. The Grant County Fair and Columbia Basin Rodeo are put on separately as complementing attractions drawing thousands of visitors. The rodeo is remembered as one of the most colorful and wildest

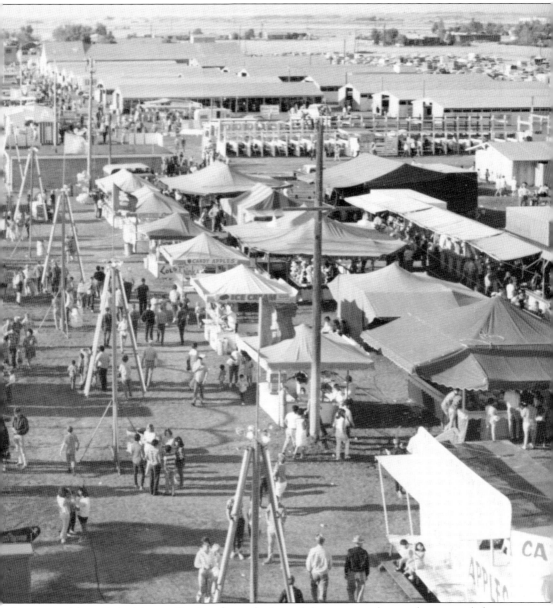

chapters in Moses Lake history. During the early days of the event, rodeo cowboys rounded up the region's wild horses by horseback, jeep, and airplane. Today, visitors enjoy a taste of the future at the phenomenally popular Space Burger booth sponsored by the Lioness Club of Moses Lake. These flying saucer–shaped hamburgers have been the highlight of the midway since 1965.

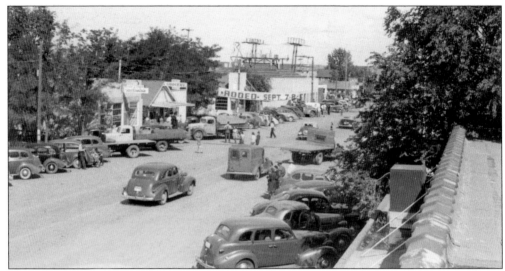

RIDE 'EM COWBOY. The Columbia Basin Rodeo Association began when 30 horsemen met at the O.K. Café and pitched in $25 apiece to put on a rodeo in Moses Lake. They donated lumber, livestock, labor, and rounded up wild horses. The first rodeo was held on September 9 and 10, 1944. Charter members of the association were Louis Giersdorf, Chris Ottmar, Mark Leighton, Dale Caldwell, John Jingling, Fred Swartz, Guy Giersdorf, Ray Dyck, Kenneth "Bud" Saunders, Eddie Penhallurik, Delbert "Red" Jones, Harold Schwab, Finley MacDonald, Frank "Tub" Hansen, J.A. Bond, Ed Robbins, Sam Driggs, Paul Dills, Lee Adley, E.B. Cole, Ed Osborne, Ruben Schaal, Bud Galloway, Walter Cole, Paul Larmier, George Ottmar, Grant Hartley, Ed Buchmann, Ivan Cole, and Louis Boyd. Above, preparations are made for the 1946 rodeo parade. Below, Eddie Penhallurick rides bareback at the 1949 rodeo. (Above photograph courtesy of Harold Hochstatter.)

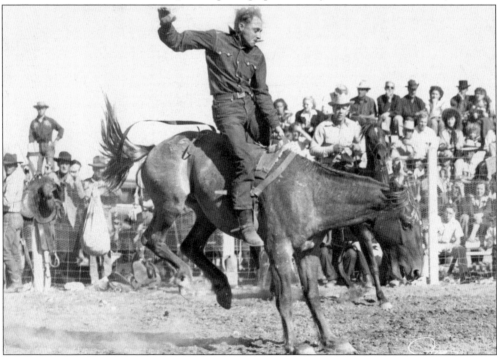

EDUCATION ON THE HOOF. Over 700 first-grade and special-education students visited the Moses Lake Future Farmers of America (FFA) at the Grant County Fairgrounds on their Farm Day tour on May 10, 1961. As part of their curriculum, students learned about the care of beef animals and saw farm equipment. From left to right are Debra Shell, Karen Searle and Niel Allen. FFA boys are Byron Ditty and Ray Prentice.

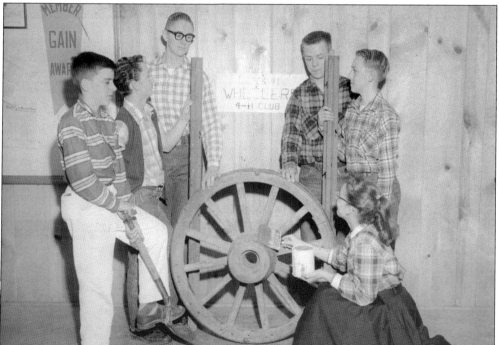

FAIR TIME. Boys and girls join the local 4-H at age 10 and start working on projects, learn how to work with people, give demonstrations, and acquire other skills that prepare them for vocational programs in high school. Here, the 4-H Wheelers are making a road sign marking national 4-H week in 1958. From left to right are Pat Palmerton, Lynn Mattson, Leonard Jingling, Bob Osborn, Paul Goebel, and Gae Palmerton.

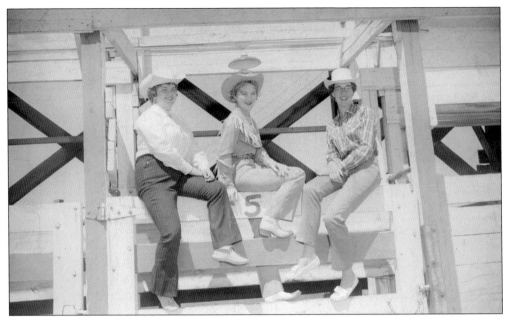

CROWNING ACHIEVEMENT. Girls from all over the Columbia Basin competed for the title of Grant County Fair and Rodeo Queen. Queen Sharla Hansen, center, of Ephrata, is accompanied by her two princesses, Marlee McKenzie, left, also of Ephrata, and Cheryl Dahl of Moses Lake. Today, Miss Moses Lake Round-up must score well in the heavily weighted horsemanship category in addition to beauty, personality, and leadership.

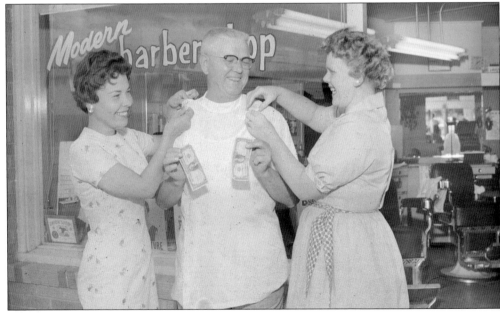

FAIR FLAIR. Mrs. Carl Kirkham, left, president of the Jaycee Jaynes, and Mrs. John Garvin, chairwoman of the Jaynes button sales committee, pin fair buttons on barber John Chamberlain. Fair buttons, which included admittance to the fairgrounds for four days, sold for $1. The 15th Annual Grand County Fair and Rodeo opened on Thursday, September 8, 1960, featuring a newly revamped sheep shed, paved sidewalks, and a $2,500 rodeo purse.

ROCK HOUND. The Adam East Museum was built to house East's collection of Native American artifacts donated to the City of Moses Lake in 1956. In 1929, noted explorer Roy Chapman Andrews, allegedly the real person that the movie character Indiana Jones was patterned after, praised it as "the best collection for its size I have ever seen." Above, East (left) and Martin Penhallick displayed the collection at the Pilot Café about 1951. East died shortly after construction began and lay in state in the unfinished museum. Below, Mayor Marshall Burress (left) and Forest Hardin (far right) greet Joe E. Farris (center, left), president of the Eastern Washington Historical Society and Prof. George Beck (center, right) of Central Washington College of Education (now Central Washington University) at the 1958 opening. Renamed the Moses Lake Museum & Art Center in 2000, the museum moved twice before the Balsam Street facility opened in 2011.

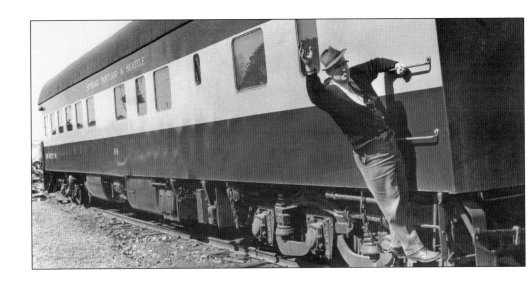

FORMER HOBO. In the grim winter of 1933, a 17-year-old hobo stood outside of a Minneapolis soup kitchen and vowed one day he would own his own train. Monrad "Monte" Holm, founder of Moses Lake Iron and Metal and Moses Lake Steel, moved to town in 1954. In 1965, he started the Mon-Road Railroad, comprised of a presidential dining car used by Pres. Woodrow Wilson and Pres. Harry Truman, the last 200-ton steam engine operated in Alaska, and a caboose on a siding next to his business. In 1975, Monte announced his plans to open the House of Poverty museum to display years' worth of antique collectables. Monte, as he is affectionately known by Moses Lakers, was a local icon, known for his warm smile and a pocketful of Werther's Original candies, both offered liberally. (Photographs courtesy of Karen Rimple.)

Five

THE BIRTH OF
A BOOMTOWN

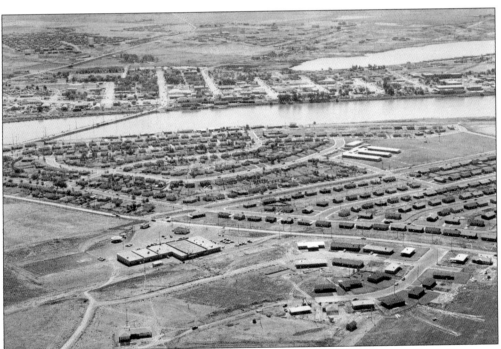

PORTRAIT OF PROSPERITY. Moses Lake, once one of the smallest communities in Grant County—smaller than Wheeler, Warden, and Wilson Creek—is now the largest. Well-scrubbed residential blocks and smart modern retail centers were popping up at every turn along with the rapidly developing Columbia Basin Irrigation Project and Larson Air Force Base in this aerial view about 1955.

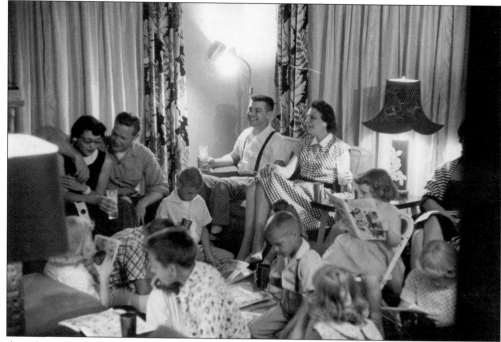

ALL-AMERICAN. In 1955, Moses Lake entered the annual All-America cities award contest sponsored by the National Civic League and *Look* magazine. The award is given annually to 10 American cities in recognition of community-wide collaboration to achieve uncommon results. The year that Moses Lake entered, 137 entries were received from 39 states. In three short years, Moses Lake was full-grown—a modern oasis in the arid desert.

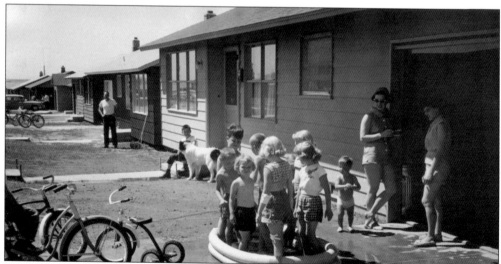

BOOMTOWN. The discovery of a precious resource—as with the 1848 California Gold Rush—usually precedes the birth of a boomtown. The Columbia Basin Irrigation Project and Larson Air Force Base threw Moses Lake a one-two punch and people streamed in eager to take part in the growing economic prosperity. However, unlike the typical boomtown, which may undergo a bust, Moses Lake's agricultural infrastructure peaks and wanes with the industry currents.

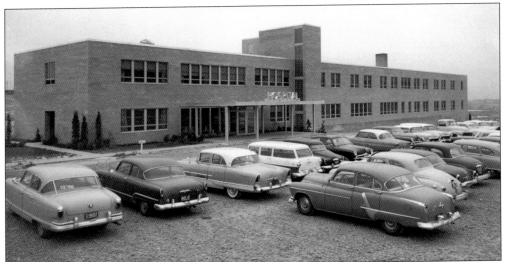

MODERN MEDICINE. A new 50-bed hospital opened in 1955. A 62-bed nursing home was added to the modern medical facilities available to residents of Moses Lake as the city's services grew to keep pace with the rapid rise in population. The first hospital was located in a converted Army barracks that also once housed the Adam East Museum and Washington State Patrol, where the Moses Lake Public Library stands today.

BABY BOOM. Ronald Paul was the first baby born in 1958 in Grant County, shown here with his mother, Sandra Bowers of Moses Lake. He was born at 5:34 a.m. in Samaritan Hospital. Also shown are Trudy Bussey, nurse, and Dr. Anson Hughes, attending physician. The post–World War II baby boom added to Moses Lake's population explosion from 2,679 (1950) to 11,299 (1960).

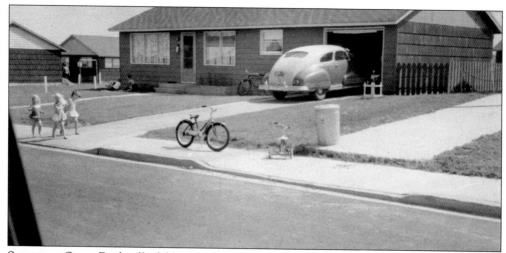

SUBURBAN OASIS. Easily affordable mortgages and pent-up consumer spending provided a recipe for realizing the dream of home ownership in the post–World War II era. More and more Americans joined the middle class, increasing demands on the reinvigorated automobile industry and spurring a postwar housing boom. The Knolls Vista, Peninsula, and Lakeview Terrace neighborhoods were a handful of the planned single-family home developments built in Moses Lake during the housing boom.

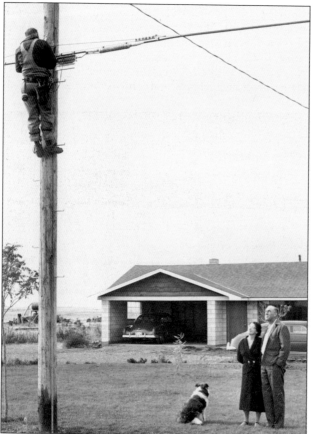

MODERN LIFE CALLS. In 1922, there were 150 telephones in use in the Moses Lake region. By 1953, Moses Lake was the fastest-growing community for telephone service in the Pacific Telephone system. Average daily calls increased from 449 per day (1945) to 11,707 per day (1953). Mr. and Mrs. Fred Lafferty watch a Pacific Telephone installer begin connection of their telephone service on Block 40.

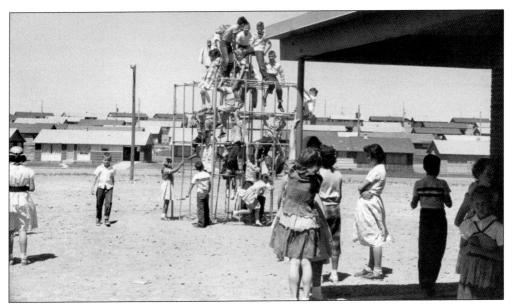

New World. Moses Lake was a new community; its people, homes, stores, schools, churches, industrial plants, and public buildings all sprang fresh from the growing prosperity of the Columbia Basin Irrigation Project. A city replete with all of the modern conveniences, Moses Lake was the new retail and service center for the growing upper Columbia Basin. A young community needed new schools to keep pace with the growing enrollment. The first surge of elementary schools built included Knolls Vista, Peninsula, and Larson Elementary, built between 1952 and 1953. One of 20 modern classrooms is shown below at Peninsula Elementary School. School playgrounds were in continuous use, such as the scene shown above, at Knolls Vista Elementary School. By 1960, there were eight elementary schools and two junior high schools, and construction was completed on a brand-new high school.

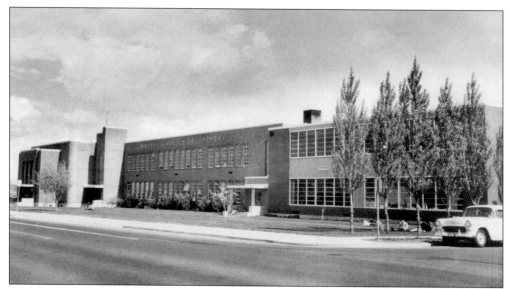

ON THE EDGE. Moses Lake High School opened in 1947 to the chagrin of many residents who considered the location at Third Avenue and Dogwood Street to be "out of town." A saturation study estimated a need for 29 elementary schools, five to seven junior high schools, and three high schools for a population of 60,000 by 1980 or 2000, based on the 1954 growth rate. A 2011 estimate places Moses Lake's population at 20,858.

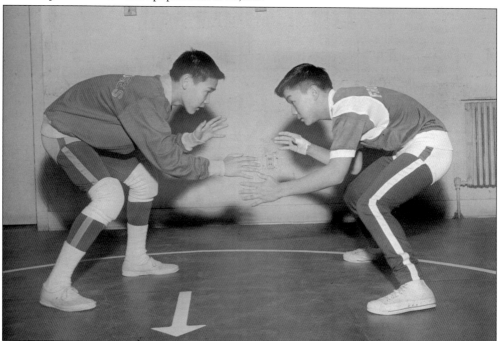

JUNIOR HIGH GRAPPLERS. Chief Moses Middle School's Bill Yoshino (left) and Frontier Junior High's Jim Yamamoto, coached by Mel Olson and Dick Deane, respectively, face off before a dual meet between Moses Lake and Ephrata mat men. Deane was inducted into the Washington State Wrestling Coaches Association Hall of Fame in 1986 for his astounding record of 281 wins, 43 losses, and 3 ties at Moses Lake High School from 1961 to 1975.

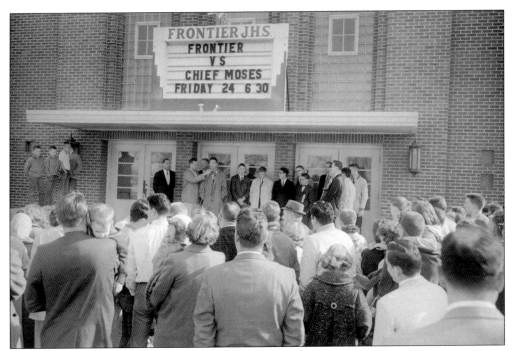

STATE CHAMPIONS, 1961. Coach Gary Frey's Moses Lake High School wrestling team returns home after capturing a third consecutive state championship. Proud citizens met the team on the steps of Frontier Junior High School, the former Moses Lake High School. A new high school was opened in 1960 after years of expedient measures, such as use of Larson Air Force barracks, were used to alleviate crowded conditions.

ALL-NIGHT FROLIC. Some 450 Moses Lake High School graduates and students swing the night away to the sounds of the Steve Laughrey Band at the all-night Senior Frolic held at the Elks building in 1960. A few partygoers kept the pace until 5:00 a.m. The night's festivities were sponsored by the Jaycees, who fundraised for the event throughout the year.

GO TEAM. A wartime moratorium on play meant only two of the 11 boys on the 1946 squad had ever played football before. That year home games were held in the rodeo arena; and as 1946 quarterback James Spidell described, it was covered in "dirt, sawdust and horse droppings." Beginning in 1950, the Moses Lake Lions Club began a years-long fundraising project for construction of a field, bleachers, and electronic scoreboard. In only 25 years of Moses Lake as a municipality, its high school athletic teams grew from Class B competition to Class AA status, playing teams from schools across Eastern Washington. Above, new Moses Lake head coach Lee Hutsell (center) and his new assistant coaches Jerry Hinton (left) and Dick Pingrey prepare to issue uniforms and equipment to the 1960 crop of grid candidates. Today, Moses Lake High School teams compete at the AAA class level.

Cage Team. Neppel's first high school basketball team was organized in 1923. In 1937, the Moses Lake High School basketball team won the Grant County basketball title. The popular "Auditorium" dance hall served as a practice spot. Coach Ed Hull (1942–1943) recalled the building had small stoves at each end and game play would pause as players stopped to repair stovepipes that had been hit by the basketball.

Whooping It Up. Sandy Sagen (left) and Venita Brown (second from left) lead an energetic yell of encouragement during a momentary time-out. The Moses Lake Chiefs battled the Quincy basketball team at a Friday night showdown in 1958. Cheerleading skirts of the 1950s were typically made of wool and remained below the knee until the 1960s brought new social norms (and shorter hemlines).

MLHS Goes Hawaiian. Following the popularity of the 1959 film *Gidget*, starring Sandra Dee, the Moses Lake High School junior class performed a stage adaptation of the film in 1960. The three male leads—from left to right, Terry Hulbert, Wally Black, and Joe Middleton—are dressed in "Hawaiian style." *Gidget* was reintroduced in 1965 as a sitcom starring Sally Field.

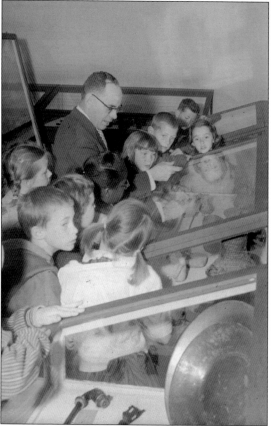

Junior Rock Hounds. Acting director of the new Adam East Museum Omar Bixler offers Mrs. Murray's third-grade class from Larson Air Force Base a preview tour of the museum a month before its official opening scheduled for May 1, 1958. Volunteers donated hours of labor to set up the museum's display cases containing artifacts from the Adam East Collection and displays on loan from other area rock hounds.

BIG BAND STATUS. The Steve Laughery Band was an instant hit on the dance band circuit in 1958. In 1960, it came within three points of winning in the American Federation Musicians Best New Dance Band National Contest in Detroit. Following Steve's death in 1972, the band reorganized as the Many Sounds of Nine. Original band members were Steve Laughery, Bob Panerio, Russ Uusitalo, Luke Danielson, and Wendell Holmstrom.

CONTINENTAL DRIFTERS. Early in the 1960s, a group of Moses Lake High School music students combined their talents as the Continentals. A rotation of members included Chuck Warren, Ken McDonald, Robert Hull, Ron Covey, Mike Balzotti, Stan Gibson, Nick Varney, Bob Gallaway, Mardi Sheridan, Marsha Mae Covey, and Jim Hay. Mike, Mardi, Bob, and Chuck released their runaway hit "Never Too Much Love" as the Bards in 1967. (Photograph courtesy of Chuck Warren.)

MARDI MIKE BOB CHUCK

♪ The Bards ♪

ERDEN RECORDING ARTISTS SEATTLE, WASHINGTON

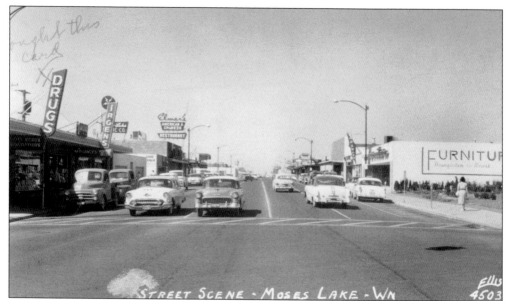

PACIN' THE BASIN. Moses Lake's catch phrase best describes its spirit of progress as Washington State's fastest-growing community from 1940–1950. A volunteer count revealed that Moses Lake continued to exceed both Wenatchee and Yakima in population growth in 1951–1952. Long-range city planning, in particular paving, became a necessary priority to bring the housing boom and downtown image into focus. A project to pave four major roads, including Broadway Avenue, was hastened to handle the anticipated crowds for the Columbia Basin Water Festival Farm-in-a-Day event on May 29, 1952. As new residents moved in, the industries and stores to serve them quickly followed. A person could find complete clothing for the men in the family at Tyson's, at West 220 Third Avenue (pictured above), or enjoy a variety of flavors in malts, shakes, sundaes, and cones at Carter's Tastee-Freez Drive-In, at West 423 Broadway Avenue. The home of Barry's Clothing, at West 122 Third Avenue (shown below), later became the Adam East Museum & Art Center in 1990 and the Columbia Basin Quiltworks in 2001.

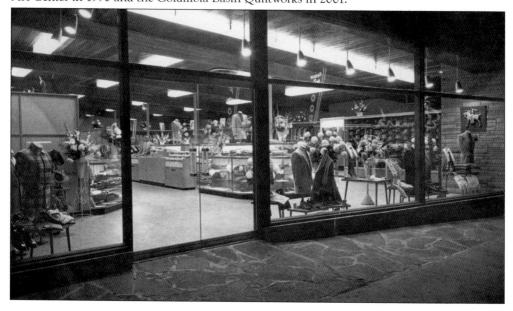

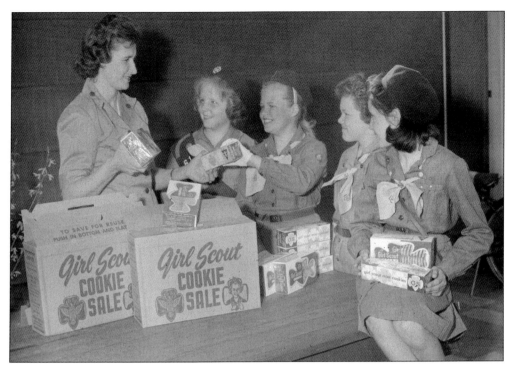

SWEET ESCAPE. The Columbia Basin Girl Scouts began their annual cookie sale on April 8, 1960. Chocolate mint and shortbread cookies were sold to raise funds for the girl's trip to King Lake Girl Scout Camp southeast of Monroe, Washington. Betty Laughery (left), of Moses Lake, passes out cookies to the girls in her troop, from left to right, Hannah Rea, Sara Waggoner, Janet Raney, and Pamela Hicks.

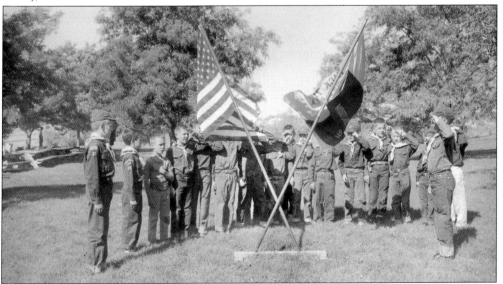

LEADER OF THE PACK. Moses Lake Cub Scouts commemorated 50 years of scouting in 1960. Here, Cub Scouts from Pack 71 in Moses Lake salute the colors at a flag-raising ceremony at Moses Lake State Park. The Scouts also planted a flowering crab tree at Samaritan Hospital that week. The Boy Scouts of America celebrated their 100th anniversary in 2010.

KEEPING FAITH. Moses Lake's faith kept pace with the town's growth. By 1965, thirty-two churches had been established, representing at least 15 denominations. A page in the *Columbia Basin Herald* was dedicated to services at Columbia Basin churches, where one could see at a glance all of the worship options. Catholic, Protestant, and Jewish services were available at the Larson Air Force Base Chapel depending on the day of the week.

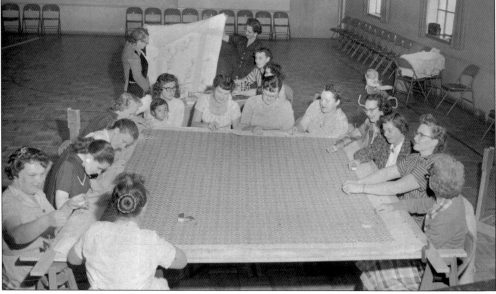

FABRIC OF LIFE. Lowell DeMille, shown fifth from the right, is the work director supervising the needlework division of the Ward II of the Church of Jesus Christ of Latter-day Saints. The group is hosting the quilting bee in preparation for an annual bazaar in 1957. A Pilgrim-themed buffet dinner was scheduled in conjunction with the bazaar.

WATERFRONT LIVING. In 1963, a waterfront home is listed in the *Columbia Basin Herald* as follows: "Lakeshore Home with Dock and Boat Ramp. Lovely 3 bedroom with 1300 sq. ft. of living area. Large living room, dining room, birch kitchen, glassed in shower, H/W floors. Underground sprinkler irrigates from lake, pump house, Beautiful Lawn, aluminum storm doors and windows. Priced at $18,250.00 terms to be negotiated."

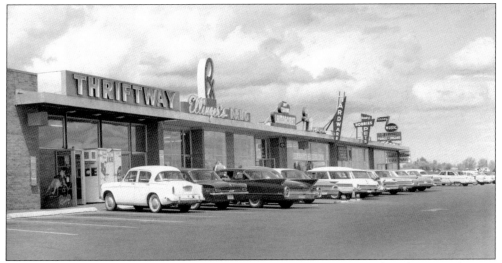

VISTA VILLAGE STAPLE. The only local delicacy Moses Laker's love as much as their spaceburgers is Chico's pizza. Operating out of the Vista Village Shopping Center for over 30 years, Chico's is the quintessential family pizzeria, with dark, heavy tables capable of seating a family of 12 or an entire sports team consoling a loss or celebrating a win. True carnivores order the Hochstatter Special.

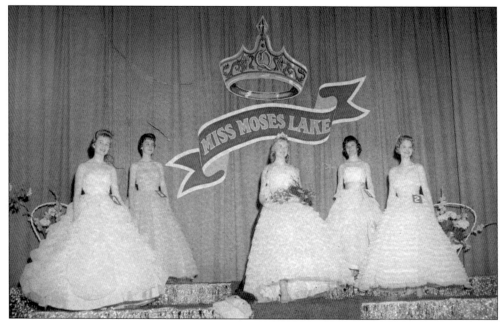

THE ROYAL COURT. High school senior Queen Carolyn I, more commonly known as Carolyn Noble, was crowned Miss Moses Lake on April 20, 1960. Shown here, from left to right, are princesses Barbara Clapp and Sandi Wahl, queen Carolyn, and princesses Lois Curtis and Kim Morgan. Tyson's clothing store at 106 West Third Avenue served as the official ballot headquarters. Quasi-election official Sally Tyson, a store clerk, reported brisk voting as the deadline approached.

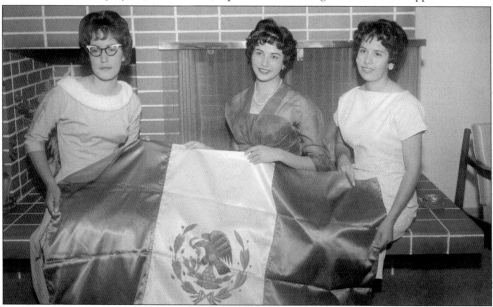

WHO WILL REIGN? Hopeful candidates for the Mexican Queen at the festival held September 4, 1960, at the Lady of Fatima Catholic Church in Moses Lake pose here with the Mexican flag. Pictured are Judy Bernhardt (left), Josie Cavazos (center), and Cuca Medrano. As the church's congregation grew to some 375 families, the newly built Lady of Fatima Catholic Church was opened for Mass on Easter 1953.

GROWTH BY THE STACKS. Completed in 1965, a new modern public library in association with the North Central Regional Library District began service in Moses Lake. A program of interchanging books and a rural bookmobile program offered library services equivalent to that of a much larger community. The building was designed by Harvey Vernier (American Institute of Architects) and features a distinctive hyperbolic paraboloid roofline and basalt rock walls.

STUDENTS FLOAT LIBRARY. As part of their campaign to bring the Columbia River regional library bookmobile headquarters to Moses Lake, members of the Grant County Student Library Committee work on the float they entered in the Grant County Fair and Rodeo parade in 1960. They also hosted a booth at the fairgrounds. Pictured, from left to right, are Paul Seibel, Patti Hogan (committee chairman), Jil Hayes, Steve Smith, and Robert Bone.

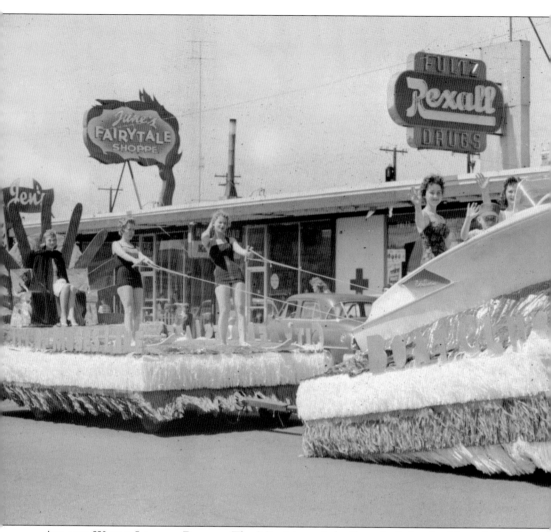

ALL THE WORLD LOVES A PARADE. The Miss Moses Lake float, built by the Moses Lake Boat Club, accompanied a march of over 450 Little League baseball hopefuls marking the Little League season opening in 1960. Moses Lake mayor Alex Law kicked off the festivities beginning with an 11:00 a.m. breakfast at Sigman's Food Store and ending with a parade down Third Avenue.

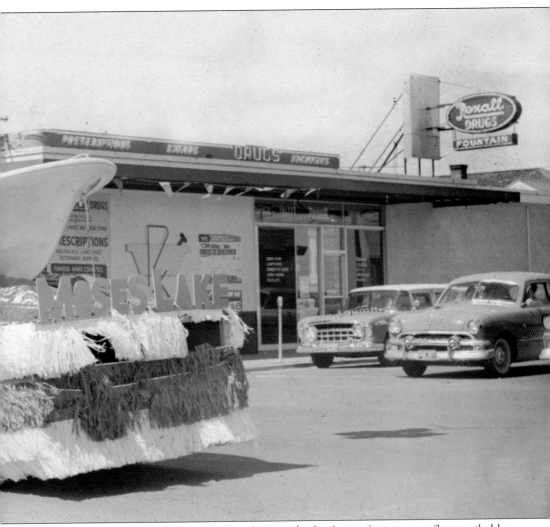

Court princesses Sandi Wahl, left, and Lois Curtis ride the front of a two-part float trailed by court water-skiers Kim Morgan and Barbara Clapp, and Miss Moses Lake Carolyn Noble sitting on a water-ski-encircled throne. A dozen boys followed the parade route on a 1919 Stutz fire wagon driven by Capt. Otto Jensen.

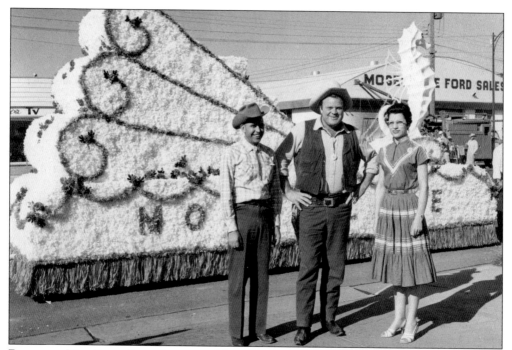

PLAYING A NEW ROLE. Better known as Hoss Cartwright of television series *Bonanza* fame, Dan Blocker attracted hundreds of onlookers to the annual 4-H and FFA Fat Livestock Auction Sale at the Grant County Fairgrounds. Blocker auctioned off a 140-pound lamb for $1 per pound. Chamber president Glenn Howell (left), Blocker (center), and chamber secretary Margaret Roberts pose at the fair's parade on September 9, 1961.

SPRING GARDEN SHOW. Members of the Lakeview Terrace Garden Club organized a garden show–themed "Symphony of Spring" at Yerxa's Florist around 1961. Entries were comprised of miniature floats 30 inches in length. Pictured, from left to right, are (seated) Mrs. Don Hara and Mrs. Art Wenz; (standing) Mrs. Richard Ottmar and Mrs. L.P. Stewart.

MANAGED GROWTH. Growth of a city means growth of its government. In 1960, Moses Lake voted to adopt the council-manager system of city government. Moses Lake City Council 1969 are, from left to right, (seated) Otto Skaug, Jack Eng, Mayor John Jones, secretary June Rector, and Dr. Ernest Lindell; (standing) Charles Davenport, city clerk Michael Boyle, Monte Holm, city manager Chester L. Waggener, and city attorney John Calbom.

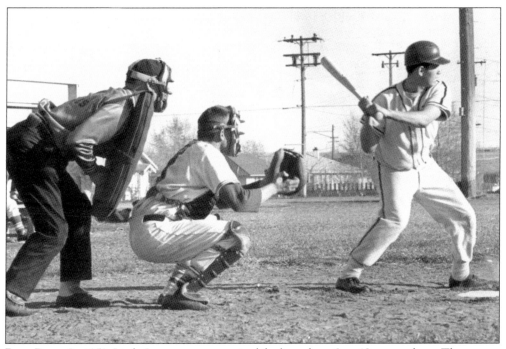

PLAY BALL. In 1953, Little League was organized for boys from 8 to 12 years of age. The season began with four teams of 50 players and expanded to six teams of 80 boys by the season close. Two regulation Little League baseball diamonds were shortly approved for Cascade Valley. Pony League baseball for boys 13 to 16 years old was organized in 1955.

CREATIVE CLIMATE. A display of 83 Washington state artists was opened at the Aero Mechanics building in Moses Lake in 1960. The Moses Lake Exchange Club project was conceived to further interest in art and culture in the Columbia Basin. Donald Bunse (left), curator at Cheney Cowles Memorial Museum, and Daisy Henry, art instructor at Moses Lake High School, sneak a peek at George Laisner's painting *Moss Agate*.

FAIR PRIZE. Lions Club members set up an award booth at the Moses Lake Parade of Progress Fair in 1958. The booth was one of 45 exhibitors at the three-day local edition of the Brussels World's Fair. The grand prize was a week's vacation to British Columbia. From left to right are Hank Rittierodt, James Mitchell, Earl Merrimand, and Russ Swanson (club president). The Moses Lake Lions Club was organized in 1941.

BETTER LIVING, 1960. Members of the newly organized Cascade Scramblers 4-H Club pose are, from right to left, (seated) Marlene Verbel, Ted Hjalatin, Margaret Ekanger, Beverly Busherd, and Roberta Hines; (standing) Linda Hull (junior leader), Becky Ladwig, Janet Orr, and Evelyn Hines (4-H leader). In 1956, Moses Lake had 19 4-H clubs with some 200 members.

MOSES LAKE ORGANIZES. Practically all of the major fraternal organizations, including the Elks, Eagles, and Moose lodges, were represented in Moses Lake about 1960. Many clubs and other organizations for both men and women included the Lions, Rotary, Kiwanis, Business and Professional Women, and the Soroptimists. Soroptimist Carolyn Noble is pictured. The Moses Lake chapter of Soroptimist International was chartered in 1955.

OLDEST CLUB. In 1914, the Moses Lake Women's Club organized; it was known then as the Neppel Women's Club. The club purchased the defunct cheese factory, on Broadway Avenue opposite the train depot, for its headquarters. The club raised money for the purchase by hosting lunches and dances. Newly installed officers in 1960 are, from left to right, Mrs. G.H. Benedict, Mrs. C.I. Wick, Mrs. J.I. Moe, Mrs. Emil Crawford, and Mrs. Clarence Sanden.

SECOND GENERATION. The Nisei Women's Club formed in 1966 as a service club for second-generation Japanese women in Grant County. Many club members were forcibly evacuated from their homes in 1942 as wartime paranoia sent Japanese Americans to internment camps or inland locations. The club hosted an annual sukiyaki dinner for up to 900 people in Moses Lake. Here, Shia Yamane (left) and Kimi Yamamoto prepare for the popular event in 1976.

120

STRIKE YOUR APPETITE. The Elmer's Restaurant bowling team won top honors in the Businessmen's League Title competition in May 1959. Team members are, from left to right, Jack Hattori, Bill Utsunomiya, Mike Hattori, Bill Utsunomiya Jr., Charles "Chuck" Kataoka, and Ich Koonishi. Kataoka moved to Moses Lake in 1954, where he farmed sugar beets, beans, and wheat, earning the title Conservation Farmer of the Year (1981–1982).

GLOYDETTES. The wives of Block 40 formed a women's club in 1952. Original members of the club were Marian Balliet, Fran Bennett, Merle Clifford, Helen Coffman, Jewell Cornutt, Rose Hamel, Evelyn Hansen, Fern Henderson, Velma Hunt, Lavon Isaacson, Lorraine Johnson, June Knopp, Jean Mackey, Marilyn Makin, Gladys Minden, June Ohland, Barbara Osborne, Gertie Osborne, Doris Peters, Virginia Pope, Lulabelle Robb, Virginia Robinson, and Amy Wright. (Photograph courtesy of Kris Chudomelka.)

OFFICERS INSTALLED. The Mynah Toastmistress Club welcomed new officers at a special installation dinner at Elmer's. Pictured, from left to right, are Lois Hall (installing officer), Virginia Cruver (president), Helen Dike (vice president), and Leona Wolfe (treasurer). Elmer's American-Chinese Restaurant, located at 117 West Third Avenue, offered a T-bone steak for $3.25 and pork chow mein for $1.10 about 1954.

GROWING SUCCESS. Chamber of commerce secretary Omar Bixler addressed the Spokane Kiwanis Club in 1956 in favor of increasing land ownership per farm unit within the irrigation project to more practical levels. Bixler said, "The city of Moses Lake is growing rapidly in step with the agricultural development and with the expansion of operations at Larson Air Force Base." Moses Lake Kiwanis Club officer installation is pictured here in 1958.

AT PLAY. Moses Lake established a fund for municipal parks and playgrounds as early as 1947. Today, the City of Moses Lake Parks and Recreation Department maintains over 200 acres of developed parkland encompassing 21 parks and numerous facilities from boat launches to ball fields. (Photograph courtesy of P.J. DeBenedetti.)

CATCH A WAVE. In 1960, Mayor Alex Law submitted a report of recommended capital improvements beneficial to Moses Lake's future, including development of McCosh Park and construction of an Olympic-sized swimming pool. The Swedburg Pool (shown) was replaced by the Moses Lake Family Aquatic Center in 1994. The aquatic center was renamed the Surf 'n Slide Waterpark in 2007 after significant expansion and the addition of a surfing simulator.

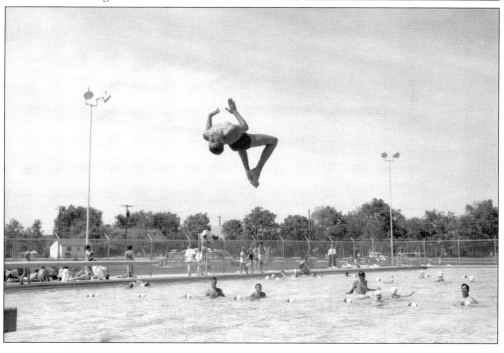

AGRICULTURAL EXCHANGE. In 1966, the Japan Agricultural Exchange Council and the Big Bend Community College Foundation launched the Japanese Agricultural Training Program (JATP). Japanese farm exchange students spend two years in the training program to learn American technology and farming methods. Host farms and host families offer trainees a firsthand experience of farm operations and the greater American experience. (Photograph courtesy of Joe Nishida.)

SISTER CITY. In 1978, recognizing the growing relationship between Moses Lake and Japan, the city council organized a committee to select a Japanese sister city. Members of the Japanese Agricultural Training Program and Japan Air Lines volunteered to assist the committee. In 1981, Moses Lake mayor Bob Hill and Yonezawa mayor Toshihide Cho signed the official "Sister City Agreement" between Moses Lake and Yonezawa City in Yamagata Prefecture, Japan.

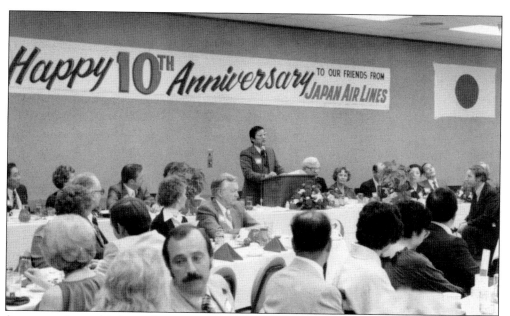

SAYONARA. Japan Air Lines discontinued its pilot-training program in Moses Lake in 2009. The new generation of aircraft no longer required the long runways that made the site so advantageous 40 years ago. Over 10,000 Japan Air Lines crew members trained at the Grant County Airport from 1968 to 2009. (Photograph courtesy of the Port of Moses Lake.)

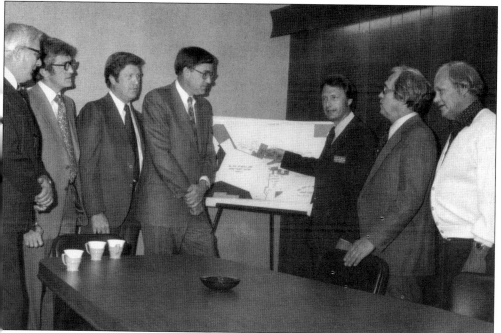

PORT EXPANSION. Affordable power is a key factor in the economic development of the region served by the Grant County Public Utility District. In 1974, the Port of Moses Lake expanded and welcomed one of its first industrial tenants, Columbia Bean and Produce Inc. Today, approximately 40 tenants ranging from silicon producers to boutique wine cellars occupy the park. (Photograph courtesy of the Port of Moses Lake.)

125

ASH SUNDAY. Mount Saint Helens erupted on May 18, 1980, sending over half a billion tons of ash and debris drifting eastward across Washington. The ashfall in Moses Lake amounted to some two million tons, bringing daily life to a grinding halt. Churches let out early, and fishermen abandoned their sport to reach home before the highways shut down. Ash blocked out the sun and smothered over $100 million in crops.

TRUE GRIT. Ingenuity blossomed, proving that even volcanic ash clouds have a silver lining. Stranded dune buggy racer Ken Ozawa developed an air filtration system that helped get service vehicles back into action. Irrigation line was laid enabling ash removal. City councilman Steve Shinn said, "We didn't know what to do with the stuff at Moses Lake, so we irrigated it. That's one thing we know how to do here."

About the Organization

Born in 1871 in Kansas, Adam H. East developed a passion for archaeological discovery at an early age. His later real estate and mining projects required him to travel across the United States and into South America, expanding his growing archaeological collection. In 1920, East became the first president and founding member of the Wenatchee-based Columbia River Archaeological Society. By 1927, East had amassed a collection of over 44,000 artifacts. In 1929, noted explorer Roy Chapman Andrews, allegedly the real person that the movie character Indiana Jones is patterned after, visited the collection. Andrews said, "This is the best collection for its size I have ever seen." In 1950, East moved to Moses Lake. He wrote to his family, "We intend going to Moses Lake, in the heart of that 1,000,000 acre irrigation system. First water is to be turned on in 1951. It is a wonderful sight. They are laying concrete pipes now. I stood in one, and it was eighteen feet to the top. So huge." In 1951, East's collection occupied a building on Stratford Road near his house. It was later moved to the vacated hospital in 1955. In 1956, East donated his archaeological collection to the City of Moses Lake and the collection occupied the Pilot Café while plans were laid to build a permanent museum. East passed away before construction was complete. Since its opening in 1958, the Adam East Museum, later renamed the Moses Lake Museum & Art Center, has expanded its mission to feed the community's growing cultural appetite. In 1990, a grassroots movement led to the establishment of the museum as a program of the City of Moses Lake's Parks and Recreation Department and the addition of a fine art gallery. In 2006, the museum was awarded a grant of $1 million from the Washington State Historical Society's Heritage Capital Project Fund. The award became part of a larger capital project merging the museum with a civic facility designed by Seattle-based architects MillerHull that also houses city offices. The Moses Lake Civic Center opened in 2011. Today, the Moses Lake Museum & Art Center is home to the Adam East Collection of Native American artifacts, a fine art gallery, exhibits exploring the history of the Columbia Basin, and the life-sized Columbian mammoth found-object sculpture by artist Jud Turner.

DISCOVER THOUSANDS OF LOCAL HISTORY BOOKS FEATURING MILLIONS OF VINTAGE IMAGES

Arcadia Publishing, the leading local history publisher in the United States, is committed to making history accessible and meaningful through publishing books that celebrate and preserve the heritage of America's people and places.

Find more books like this at
www.arcadiapublishing.com

Search for your hometown history, your old stomping grounds, and even your favorite sports team.